HOW BLACK FEMALE OFFENDERS EXPLAIN THEIR CRIME AND DESCRIBE THEIR HOPES

A Case Study of Inmates in a California Prison

How Black Female Offenders Explain Their Crime and Describe Their Hopes

A Case Study of Inmates in a California Prison

La Tanya Skiffer

With a Preface by
Sharon Bethea

The Edwin Mellen Press
Lewiston•Queenston•Lampeter

Library of Congress Cataloging-in-Publication Data

Skiffer, La Tanya.
 How black female offenders explain their crime and describe their hopes : a case study
of inmates in a California prison / La Tanya Skiffer ; with a preface by Sharon Bethea.
 p. cm.
 Includes bibliographical references and index.
 ISBN-13: 978-0-7734-4916-9
 ISBN-10: 0-7734-4916-7
 1. African American prisoners--California--Case studies. 2. Women prisoners--
California. 3. Female offenders--California. 4. African American women--California--
Biography. I. Title.
 HV9469.S58 2008
 364.3'74089960730794--dc22
 2008046943

hors série.

A CIP catalog record for this book is available from the British Library.

Front cover art by Danny Madrid

The Edwin Mellen Press
Box 450
Lewiston, New York
USA 14092-0450

The Edwin Mellen Press
Box 67
Queenston, Ontario
CANADA L0S 1L0

The Edwin Mellen Press, Ltd.
Lampeter, Ceredigion, Wales
UNITED KINGDOM SA48 8LT

Printed in the United States of America

To my mother Carolyn Frazier-Barr with whom I have spent many years
discussing the plight of female offenders worldwide.

TABLE OF CONTENTS

Preface by Sharon Bethea, PhD .. i

Acknowledgments .. iii

Chapter

1. INTRODUCTION ...1
 Studying Causal Attributions for Crime2
 Gender, Race, and Attributions ...3

2. LITERATURE REVIEW ...5
 Gender Dimension of Crime..6
 From Pathways to Attributions ...10

3. THE IMPORTANCE OF PERCEPTIONS AND ATTRIBUTIONS23
 Theory: The Social Psychology of Causal Attributions25
 Offender-Based Research ...28
 Racialized Attributions About Crime ...35
 Locus of Control for Crimes ..36
 Consequences of Attributions About Crime41

4. METHOD AND PROCEDURES ...45
 Sample and Setting ...45
 Procedures ..47
 Analysis ..52
 Operational Definitions of Coding Categories53

5. RESULTS ... 57

 Causal Relationships of Crime ... 58

 Typology of Crime Attributions ... 71

 Racialized Attributions About Crime 73

 White Women Offenders .. 80

 Other Women Offenders .. 86

 Gendered Attributions About Crime .. 88

 Locus on Control for Crimes .. 93

 Consequences of Attributions About Crime 95

6. DISCUSSION AND IMPLICATIONS ... 99

APPENDIX

1. Operational Definitions of Coding Categories 105

2. Research Project Interviews Recruitment Flyer 111

3. Background & Demographics... 113

4. Consent Form... 115

5. Oral Script... 117

6. Views & Perceptions of What Causes Crime: 119

REFERENCES ... 125

INDEX .. 137

PREFACE

It is with great pleasure that I write this preface. This book is an important text that makes significant contributions to the study of female criminality. For the reasons that this work makes abundantly clear, Black female offenders represent an important group of female offenders that deserves serious attention, which they had not previously received. It is important to explore firsthand Black women's experiences with crime and criminality.

Although in the last twenty years the increasing presence of women in multiple correctional systems has sparked an interest in feminist research in the area of women's pathways to imprisonment, the number of academic studies done from the perspective of women remains quite small. Most criminologists have focused on male offenders' perceptions of crime, primarily using quantitative methods. Research on Black women offenders has suffered researchers neglect for several decades.

The need for an alternative analysis of the realities of various aspects of women's criminality is why this book is such a contribution to the field of criminology. Furthermore, it is important to allow Black female offenders to voice their knowledge and expertise as informants concerning their criminality. No other academic study provides such a detailed perspective of Black women offenders' attributions for their own criminal behavior. Professor Skiffer begins with four broad research questions: (1) Do Black female inmates make more internal or external attributions in regard to their crimes? (2) Do Black female inmates make more internal or external attributions in regard to others crimes? (3) What are Black female inmates hopes and dreams for their future? (4) How do Black female inmates compare their hopes and dreams for their future with other women's future hopes and dreams?

She begins with a literature review grounded in current information about women who are involved in the criminal justice system. Professor Skiffer has

included a considerable amount of work on the "male-stream" review of the literature on women in prison. Additionally, she provides a detailed review of some of the most important feminist works, particularly work directed at Black women in prison. Skiffer then presents her theoretical framework, which is guided by a sociological theory of attributions. From this chapter, we begin to get a more complete picture of the complexities and consequences of causal attributions. After presenting her research methods and procedures, Professor Skiffer summarizes the results of the study and places them within the larger context of feminist work on pathways to crime and the social psychology of causal attributions.

Dr. Sharon Bethea
Northeastern Illinois University

ACKNOWLEDGMENTS

I would like to acknowledge the women at the California Institution for Women who so graciously participated in this study. Without the openness and willingness to share their life experiences and their time, this project could not have gone forward. I would also like to thank my committee members, Dr. Barbara Bank, Dr. Joan Hermsen, Dr. Wayne Brekhus, and Dr. Michael Lambert who have provided support and invaluable feedback throughout the development and completion of this project. Furthermore, I would like to acknowledge the prison staff and administrators who provided invaluable feedback as well as support throughout the data collection and writing process. I would especially like to acknowledge Lt. Larry J. Aaron who served as my institution chaperone for the duration of the data collection. I am forever grateful to Lt. Aaron for supporting this project and providing invaluable insight. His kind words and encouragement continue to be a source of inspiration. I must also thank my advisors, Dr. John Galliher and Dr. Tola Pearce, for their continued mentorship and guidance. Your support and encouragement are immeasurable. Finally, I must acknowledge the contributions of my friends and family. Many thanks to: Mom, John, Lynette, James, Nelson, and Tre, and Tate. Many more thanks to my best girlfriends: La Shawn Cullins, Benetta Standly, Dr. Sharon Bethea, and Dr. Yolanda Hood.

CHAPTER ONE:

INTRODUCTION

Although it is true that a rich stream of literature now exists in which issues related to women's pathways to crime have been thoroughly examined, the majority of these studies have not examined women's attributions for criminal behavior. In the last 20 years the increasing presence of women in multiple correctional systems has sparked an interest in feminist research grounded in the area of women's pathways to imprisonment, while additional insight about women's offending trajectory has also been gleaned from journalistic stories (Heidensohn 1985; Curran and Renzetti 1994; Chesney-Lind 1997; Johnson 2003). The themes of social control, patriarchy, social structural obstacles, societal abuse, and victimization are most proximate in this important body of work (Chesney-Lind 1999; Heidonsohn 1985; Arnold 1990; Richie 1996; Owens 1998; Bush-Baskette 1999). Yet despite this increased interest amongst feminist scholars, little additional scholarly research has actually been conducted on the topic of women's perceptions of what causes crime. Research on the intersection of race, gender, and crime is particularly scarce (Richie 1996). In the following chapters these questions are investigated by looking at what black women said and identifying what factors they attribute other women's criminality to.

In spite of the aforementioned efforts to study women's criminality and challenge the stereotypical characteristics of them as "demonic or deranged," questions remain about the root causes of female criminality. Furthermore, while

the overall U.S. prison population has grown, so to has the number of female offenders behind bars. This study contributes to the current feminist literature grounded in the area of women's pathways to crime by developing a typology of women offenders from the perspective of black women offenders behind bars. Additionally, this study contributes to the social psychological literature concerning attributions for behavior.

Studying Causal Attributions for Crime

I believe that it is important to explore firsthand women's experiences with crime and criminality. Although there have been numerous studies of prisoner's perceptions of crime, most have been quantitative and involved male inmates. Few studies have focused on women's perceptions of what causes crime, while no study has focused on black women's perceptions of what causes crime. How people understand their own and others behavior is an important perspective often overlooked by social scientists.

I raise the issue about causes of female criminality here because it goes to the heart of the issues that feminist criminologists must contend with as they conduct policy-oriented research. Particularly, understanding how individuals make sense of life's inevitable highs and lows can provide valuable insight for researchers, policy makers, and the public alike. Social psychologists term this phenomenon "causal attribution" (Weiner 1986). An important dimension of causal attributions involves the explanation of why events occur in one's life. Those individuals that explain past events in their lives in mostly positive terms tend to have higher self-esteem or a sense of self-worth. In contrast, those individuals that explain their past in mostly negative terms tend to suffer from low self-esteem and defeatism as well as numerous other physical and psychological ailments. Thus, a positive or optimistic outlook in relation to one's past has benefits for one's future outcomes. This point is supported by numerous studies (Forsyth 1980; Brickman 1982; Crittenden 1983; Weiner 1986; and Nair 1994).

Gender, Race, and Attributions for Crime

The major research questions attempt to truly understand women's offending trajectory from the perspective of black women behind bars. Women's attributions for causes of crime especially represent a major gap in the literature on women's engagement in crime. The following broad questions guided this research:

1. Do black female inmates make more internal or external attributions in regard to their crimes?

2. Do black female inmates make more internal or external attributions in regard to others crimes?

3. What are black female inmates' hopes and dreams for their future?

4. How do black female inmates compare their hopes and dreams for their future with other women's future hopes and dreams?

One of my goals was to allow female offenders to voice their knowledge and expertise as informants concerning their reasons for being involved in the activity that led them to prison. The question becomes: Why are black women so over-represented in our nation's jails and prisons? I believe the answer to this question lies in the life experiences of incarcerated black women. The rest of this book will concentrate on exploring the answer to this very complex question. In Chapter two, I present a literature review grounded in current information about women who are involved in the criminal justice system. In this chapter I also include a considerable amount of work on the "male-stream" review of the literature on women in prison. Additionally, I review some of the most important feminist work, particularly work directed at black women in prison. Chapter three presents my theoretical framework, which is guided by a sociological theory of attributions. Here, I elaborate on the social psychological approach known as attribution theory and causal interpretations about crime. In addition, I demonstrate how this theory is grounded in my data.

In Chapter four, I focus on my research methods and procedures. Specifically, I focus on my sample and setting, procedures, and analysis in this

chapter. Furthermore, I illustrate that in-depth, semi-structured interviews with incarcerated women is an appropriate way to explore women's attribution of criminal behaviors. Lastly, Chapter five summarizes the results of my research study. Additionally, Chapter five places my results within the larger context of feminist work in regard to pathways to crime as well as the social psychological approach causal attributions. In this chapter I will also present the theoretical contributions of my study to feminist perspectives on women and crime.

Finally, Chapter six discusses the implications of this research project. This chapter includes a summary of the major research findings in regard to black women inmates' perceptions of what causes crime. Additionally, implications of black women's hopes and dreams for their future will be presented here. The findings are examined in light of the prevailing research literature on inmates' perceptions of crime causation.

CHAPTER TWO:
LITERATURE REVIEW

The importance of causal attributions of crime cannot be underestimated. Causal attributions play a major role in judgments of suitability and decisions to parole (Carroll and Payne 1976). Causal attributions have also been determined to influence goal revision and how individuals respond to both positive and negative feedback (Tolli and Schimdt 2008). One of my research concerns was to understand what black women inmates think causes crime. A large literature, describing numerous research projects, has appeared on the topic of women offenders. In particular, this chapter will present literature in which issues related to women's crime, particularly crime committed by black women, have been examined. Additionally, the chapter presents current statistics describing the growth of the U.S. female inmate population as well as the impact of the "War on Drugs" legislation on women offenders. Finally, the chapter closes with a review of feminist literature regarding women's pathways to crime.

The topic of rising incarceration rates represents a hot-button political issue in the United States and women represent the fastest growing population in U.S. prisons and jails. Researchers have long argued that women's crimes may simply reflect the unique structural conditions they experience in society. The female inmate population experienced unprecedented growth by the end of the twentieth century (Young and Reviere 2006). Throughout the 1980s and 1990s, there was a proliferation of punitive crime control legislation, which has managed

to sweep clear across the nation. Subsequently, the U.S. has the highest rate of female imprisonment in the entire world. In fact, between 1993 and 1995, twenty-four states including California, Texas, and New York, as well as the Federal Government, enacted the controversial "Three Strikes and You're Out" legislation. Furthermore, the abolishment of parole board hearings and good time credits, the prosecution of youth as adults, and sentence enhancements by both state and federal governments represent more recent punitive measures instituted.

The Gendered Dimension of Crime

Although contemporary feminists passionately contend that traditional theories of crime etiology cannot adequately explain the experiences of delinquent girls or women, several studies have been conducted that are related to an overall discussion of women's crime and criminality. Official estimates of the number of women involved in crime have increased dramatically over the past two decades and numerous studies have documented individual and social demographic characteristics of the population of U.S. female offenders. The following statistics highlight the extent to which women are represented in the United States criminal justice system. According to Harrison and Beck (2005), the population of incarcerated women in the U.S. totaled 103,310 at midyear 2004. Currently, California leads the nation with 11,694 incarcerated women, while Texas is a close second with 10,343 (Bureau of Justice Statistics 1999). Thus, the 1990s saw an 8.4% increase in the female inmate population nationally (U.S. Bureau of the Census 2000). Regionally, the South has the largest population of incarcerated women with 37,525, followed by the West with 19,333 (U.S. Bureau of the Census 2000). Moreover, during the period of time from 1990 to 2005, the state of California's prison population grew at three times the rate of the national population (Bailey and Hayes 2006). Thus, according to the Public Policy Institute of California, a think tank, there were 167,698 men and women in California prisons at year-end 2005.

When reviewing the Bureau of Justice Statistics (BJS) Special Report on women offenders, several facts stand out. Almost two-thirds of women under probation supervision are black, Hispanic and/or other races, while another one-third are white women. In regard to BJS estimates of the prevalence of imprisonment among women by race, the lifetime chance of being incarcerated indicate that 36 out of 1,000 black women and 15 out of 1,000 Hispanic women will be imprisoned during their lifetime (Bureau of Justice Statistics 1999). Moreover, 5 out of 1,000 white women will be incarcerated during their lifetime (Bureau of Justice Statistics 1999). Not surprisingly, the future in America's prison saga does not look any brighter. According to a 2008 report by the Pew Research Center on the States, 1 in 100 black women in their mid-to late-30s are incarcerated in the U.S. Hispanic women have an incarceration rate of 1 in 297, while 1 in 355 white women are behind bars.

Furthermore, research shows that women offenders are disadvantaged under federal/state sentencing guidelines and mandatory minimum penalties. For instance, previous research suggests that women offenders are particularly vulnerable to punitive legislative cure-all's, many of which appear under the rubric of "three-strikes and you're out." Opponents critique "three-strikes" and mandatory minimum sentencing guidelines for there broad and substantial impact on women offenders. According to Raeder (1993), between 1981 and 1991, the number of women inmates under federal custody grew from 5.4% to 7.6%. In fact, from 1985 to 1995, the number of individuals under custodial care in state or federal prisons or jails virtually ballooned. In 1985 there were 742,579 inmates in the United States, 21,400 Caucasian women and 19,100 black women. In 1995, there were 1,577,845 prison inmates, with 57,800 and 55,300 Caucasian and black women, respectively. According to the Bureau of Justice Statistics (1999), between 1986 and 1991 the total state prison population grew by 58%. The number of men incarcerated increased by 53%, while the number of women incarcerated increased by 75%. Additionally, the number of women offenders per capita under probation and parole supervision rose by 40% and 80%, respectively,

while the jail rate increased by 60%. By 1998, there were an estimated 950,000 women under the care, custody, or control of U.S. correctional agencies (Bureau of Justice Statistics 1999). The majority of these cases were drug-related (Bureau of Justice Statistics 1995). Thus, more women are being incarcerated, in part, because more women are being sentenced for federal drug crimes and mandatory drug and minimum sentencing laws (Raeder 1993; Johnson 2003).

Although women remain underrepresented in violent crime offenses, women's involvement in violent crimes is also on the rise. There are 20,100 women incarcerated for violent offenses, while 18,500 are jailed for property offenses (6,900 fraud), and 23,900 are incarcerated for drug offenses (Sourcebook of Criminal Justice Statistics 1995). During the period 1993-1997, violent crime victims attributed their victimization to an estimated 2.1 million women offenders (Bureau of Justice Statistics 1999). Women account for about 14% of violent offenders—annually approximately 2.1 million.

Overwhelmingly, the exorbitant increase in women's confinement rates is due to low level drug abuse violations (e.g. sale, manufacture, possession) which produced approximately 1.5 million arrests in 1996 (Bureau of Justice Statistics 1994). Moreover, Bush-Baskette (2000) contends that mandatory minimum sentencing laws are responsible for the drastic increase of incarcerated black females. Bush-Baskette (2000) argues that the majority of offenses involve low levels of crack cocaine but result in longer sentences for black females. The "War on Drugs" legislation emphasized the removal and incarceration of low level drug dealers, which many recognized would have little, if any, effect on the drug trade. Tonry (1995) finds that there have been three effects of the "War on Drugs"; its failure, its cumulative effects on prisons and jails, and its deleterious effects on the urban black underclass.

Although many researchers have documented the prevalence of drug abuse experienced by incarcerated women, little is known of the root causes of this abuse for these women. Findings from the Texas Women Inmates Study, conducted between 1999-2000, reveals that female inmates with substance abuse

problems have extensive histories with a multitude of challenges such as childhood maltreatment, adult victimization and mental health problems, as well as delinquency. Hill (1999) sums this up with the following statement:

> An attempt must be made to understand the women we are incarcerating and the experiences they have on the inside before we can ever begin to decrease recidivism rates through additional educational and vocational programming. (P.12)

Statistics show that 57.2% of all women in prison report some sort of abuse prior to their incarceration. Forty-six percent report physical abuse, 39% report sexual abuse, and 28% report that they have been both physically and sexually abused. Thirty-three percent report that they have been raped, while 36.7% report that these crimes occurred while they were under the age of 17 (Sourcebook of Criminal Justice Statistics 1995). These findings lead Carroll (1997) to conclude that age offers little protection from assaults for African American girls, as far too many inhabit hazardous and hostile environments.

Furthermore, fundamental damage caused by the experience of abuse carries consequences for girls' later academic performance. Glick and Neto (1977), in their comprehensive study of women in selected prisons and jails, found that less than sixty percent had graduated from high school, while fifteen percent had only an elementary school education. Moreover, approximately 30% of female offenders read below the fifth grade level. The fact remains that female offenders are overwhelmingly poor, undereducated, lack vocational skills, and have extensive histories of physical, sexual, and/or emotional abuse.

These findings led Heidensohn (1985) to conclude that women are socially controlled by enormously limiting forces in the home, in public, at work and via social policies. Heidensohn (1985) describes these challenges with the following statement:

> I should like to suggest that women face distinctively different opportunity situations and to some extent with agencies of control, the main point with

the latter being that women face an additional series of controls. They are the one section of society whose policing has already been 'privatized', even though they have not ceased to be publicly controlled as well. (P. 198)

From Pathways to Attributions

It is fair to say that a fairly rich stream of literature in regard to women offenders has emerged in the last thirty years. In this section, I review a host of necessary reads for anyone examining women and crime. Additionally, I discuss weaknesses of these studies as well as my contributions to this area of investigation. In 1973, Watterson offered an insightful account of women behind bars. Thirteen years later, in a revision of *Women in Prison: Inside the Concrete Womb* (1996), Watterson laments that the situation for women behind bars has worsened since the publication of her first edition. In her study, Watterson relies directly on women's stories as they unfold in in-depth life history interviews and statistics from the American Correctional Association. Additionally, the author interviewed hundreds of women guards, wardens, superintendents, and other staff and concludes that the culture and class realities of the economically powerless are not easily comprehended by legal professionals. Watterson (1996) sums this up with the following statement:

> Crime in America is equated with primitive physical actions. The more intellectual synthesis, abstraction, and creativity in a crime, the less it is perceived as crime and the more it interests lawyers, prosecutors, and judges—who basically live by the intellectual, rather than by action. The same is true of the general public, who condemn a crime of violent action before an intellectual crime that results in an equal or greater harm to the victim. (P. 24)

Although Watterson (1996) touches on numerous important issues surrounding women's lives in prison, she does not touch on women's perceptions of why they ended up incarcerated in the first place. In fact, researchers have long argued that women's crimes (prostitution, drug-related offenses) may simply reflect the

unique structural conditions they experience in society. Moreover, Mullings, Pollock, and Crouch (2002) argue that criminal activity among female offenders continues to be primarily in the areas of crime long associated with them, such as larceny (shoplifting) and forgery (checks and credit cards).

Furthermore, Heidensohn (1985) draws on theories of social control to show how women's behavior is both confined and controlled in private and in public. In her book *Women and Crime: The Life of a Female Offender*, the author explores deviant women and female criminality as seen by society and the women themselves. Heidensohn (1985) goes on to critique classical and contemporary criminologists' explanations of women's criminality. The author argues that the nuclear family, police, courts, jails, prisons, and the law all too often function as both defining and controlling apparatuses for women's behavior. Heidensohn (1985) primarily focuses on how women offenders view themselves vis-à-vis traditional gender roles. What is missing from Heidensohn's (1985) analysis is an understanding of how women offenders understand their criminal behavior and pathways to crimes.

As stated earlier, research on women and crime did not rise to prominence until the late 1960's. Feminist criminology is defined as criminological research and theory that places women at the center of the analysis. Feminist criminologists have also advanced theories that have attempted to describe women's engagement in crime or what feminists have termed "pathways to crime." For example, Arnold (1990), in her study of the relationship between victimization and offending among black girls and women, found that young black girls' "precriminal" behavior may be more appropriately characterized as active resistance. Precriminal behavior typically involves running away from home, stealing, truancy, and/or dropping out of school altogether. The data were collected via participant-observation, interviews, and questionnaires distributed to 50 black female prisoners in a city jail and 10 women in a state prison (Arnold 1979; Arnold 1986). Arnold (1990) sums up the consequences of resistance for girls with the following statement:

> Typically, young black girls who engage in these behaviors will pay a tremendous price for resisting. Such a price will be exacted upon them by the criminal-justice system, sometimes in conjunction with parents or legal guardians. They may be labeled as status offenders, institutionalized in girls' homes, or imprisoned for vagrancy and other nonviolent crimes. Once this process of criminalization is set in motion, sustained criminal involvement becomes the norm as well as a rational coping strategy.
> (P. 153)

Arnold's theory is complex. Arnold (1990) evaluated this process along two dimensions: victimization and criminalization. The victimization dimension includes patriarchy, family violence, economic marginality, racism and mis-education, while the criminalization dimension includes structural dislocation, association with deviant and criminal others (including drug addicts), processing and labeling as a status offender, and re-creation of familial relationships in the criminal world (Arnold 1990).

The following are illustrations of Arnold's (1990: 154) victimization dimension. Patriarchy is defined as exploitation, domination and oppression by fathers, stepfathers, or stand-in fathers. Family violence is defined as sexual violence such as rape, incest, molestation, physical abuse, verbal abuse, child abuse and neglect, and mental and emotional abuse. Economic marginality is characterized by class oppression based on ascribed characteristics and lack of a solid economic base such as intergenerational poverty and welfare, inexperience and lack of skills, and low-wage employment. Finally, racism and mis-education are characterized by differential treatment based on ascribed characteristics such as skin color, hair, and facial features by authority figures and institutions (e.g. teachers, schools, school administrators, juvenile authorities, and law enforcement officials).

The following are characteristics of Arnold's (1990: 158) criminalization dimension. Structural dislocation is defined as being irreparably separated from a social institution such as the family or school. Labeling is the act of being processed and designated as a status offender (e.g., truancy, promiscuity,

incorrigibility, and running away from home) (Arnold 1990). Sutherland's (1939) differential association theory posits that crime is learned via the same social interactions that so-called normal behavior patterns are learned. Differential association is defined as associations with deviant and criminal others in place of absent healthy nuclear family relationships. Finally, the family is recreated in the form of pseudo-families among delinquent groups.

Arnold (1990) concludes that the relationship between race, class, and gender oppression in tandem with structural dislocation from major social institutions such as family, school, and work create a process of victimization, labeling, and subsequent criminalization for black women prisoners.

Indeed, Mann (1996) examined the subculture of violence theory in regard to women's criminality. According to Mann (1996), female violence stems from the same cultural and structural roots as male violence. The author examined female criminal homicide offenders in her book *When Women Kill*. She selected six cities (Atlanta, Baltimore, Chicago, Houston, New York City, and Los Angeles) with homicide rates equal to or higher than the national rates for both 1979 and 1983. Two hundred and ninety-six cases were analyzed; 77.7% of respondents were black, 12.8% were white, and 9.5% were Latina. The women ranged in age from 12 to 65 years-old and 69.5% were mothers. In regard to victims, males (80.7%) and African Americans (74.3%) were overrepresented; 15.5% were white and 10.1% were Hispanic. Results showed no support for the subculture of violence theory and only minimum support for the southern subculture of violence theory. Moreover, Mann found no support for racial bias in the criminal justice system. Not surprisingly, seventy percent of female-perpetrated homicides occurred in the home; the majority also involved a claim of self-defense, and the use of alcohol (1/3rd). Although Mann (1996) adds much to our understanding of female-perpetrated violence, much still remains unknown about the root causes of this behavior. This study will add insight into women's behavior from the perspective of women.

One of the most well known works on women's crime is Beth Richie's book *Compelled to Crime: The Gender Entrapment of Battered Black women*. Richie (1996) examines the complex link between gender-identity development, violence, and crime. Utilizing life history interviews conducted with thirty-seven women incarcerated at Rikers Island, Richie constructs an alternative model of female criminality. According to Richie (1996), some women participate in crime in response to violence, threats of violence, or coercion by male partners. Thus, Richie contends that patriarchy, racism, class, and physical and sexual abuse compel many women to crime. Richie outlines six pathways to crime for battered black women. They are: (1) women held hostage, (2) projection and association, (3) sexual exploitation, (4) fighting back, (5) poverty, and (6) addiction. Furthermore, Richie (1996) advances an even more powerful contention that self-reliant and independent black girls who become strong black women were more likely to be battered than those who did not. In contrast, this study allows women offenders to voice their attributions regarding causes of crime.

In fact, Chesney-Lind (1997) reports that young women are also disproportionately subjected to intensive social control by family members and agents. "A prevalent theme in the work of Chesney-Lind (1988) and Chesney-Lind and Rodriguez (1983) suggests the existence of a systematic process of criminalization unique to women that magnifies the relationship between ongoing societal victimization and eventual entrapment in the criminal justice system" (Arnold 1990: 154). Chesney-Lind (1997), in her book *The Female Offender*, found that girls were more likely to have abuse histories (originating in their family of origin) and to be arrested for "status offenses." "Status offenses" include noncriminal behaviors that violate parental authority, such as "running away from home," being "a person in need of supervision," "a minor in need of supervision," "incorrigible," "beyond control," "truant," or in need of "care and protection." Chesney-Lind (1997) sums this up with the following:

The juvenile justice system . . . should be understood as a major force in the social control of women, because it has historically served to reinforce the obedience of all young women to the demands of familial authority, no matter how abusive or arbitrary. (P. 17)

Another important contribution to the understanding of women's engagement in crime is Barbara Owens' book *In The Mix: Struggle and Survival in a Women's Prison.* Owen (1998) examines women's prison culture via the analysis of 294 face-to-face interviews (randomly selected) and systematic survey data on women incarcerated in the Central California Women's Facility (CCWF). Specifically, "the mix" is defined as "a continuation of the behavior that led to imprisonment that ties life in prison to life before and after prison" (Owen 1998: 3). According to Owen (1998), too many women's lives have been shaped by a combination of personal issues and social structural obstacles. Owen (1998) argues for three central pathways to imprisonment for women offenders: (1) multiplicity of abuse in their pre-prison lives, (2) family and personal relationships (male partners and children), and (3) spiraling marginality. Owen (1998) sums this up with the following statement:

The personal domains of drug and substance use, physical and sexual abuse, oppressive relationships with men, and the lack of economic skills shape their immediate experience. The structural domains of racism, sexism, decreased economic opportunity, and the devalued status of women, particularly marginal women, limit their access to conventional roles. (P. 40)

Owen focuses on women's prison culture and the gendered response to imprisonment.

According to Cook and Davies (1999), now more women than ever before are being criminalized and imprisoned, ultimately, for transgressions against the laws of nature that purports that women are supine and nurturing creatures. In their edited volume, *Harsh Punishment: International Experiences of Women's Imprisonment*, Cook and Davies (1999) tackle the complex issue of women imprisoned throughout the world today. Cook and Davies examine current trends

in women's imprisonment in the United States, Canada, England, New Zealand, Poland, and Thailand. Several major trends were discussed. One such trend is the dramatic increase in women's imprisonment worldwide. Whether speaking about the United States, Canada, England, New Zealand, Poland, or Thailand, the fact remains the same: women's rates of imprisonment are rising faster than men's.

Cook and Davies edited volume also features numerous articles dedicated to women's rights. For instance, Bush-Baskette (1999) explores the impact that the "War on Drugs" had on low-level drug dealers and street-level drug possession and trafficking crimes. The 1970s and 1980s saw a shift in focus of state and federal legislators towards mandatory minimum sentencing laws, stricter enforcement, and enhanced penalties primarily for violations of drug laws. During this turbulent decade, women's rates of incarceration increased exponentially, primarily for nonviolent property crimes and drug offenses. Bush-Baskette (1999) sums this up with the following statement:

> I posit that women were the easy targets of the war on drugs for two reasons: first, because of the history of drug use by women in the general population and the high prevalence of drug abuse among the incarcerated female population; and second, because of a combination of the media's depiction of the crack epidemic and the alleged culprits, the resulting public fear and concern, and political necessity. (P. 212)

Bush-Baskette (1999) considers several important social facts with regard to women and drug use. For example, it is a well-known fact that historically, physicians have over prescribed sedatives and tranquilizers, or so-called "happy pills," to female patients. Subsequently, middle-class women enter emergency rooms for treatment of drug overdose at higher rates than their male counterparts. Additionally, Bush-Baskette (1999) highlights the multiplicity of traumas experienced by women behind bars. According to Bush-Baskette, sexual abuse, rape, and incest as well as economic pressure often lead to depression and the use of drugs to cope. Bush-Baskette (1999) sums up the motives for this drug use for women with the following statement:

Depression often precedes the use of drugs by women, and drugs of any types may be used to deal with the depression. Some women use drugs as a means of self-medication to cope with the devaluation of women in general and the resultant low self-esteem. Traumas of a personal nature such as rape, incest, and other sexual abuse, as well as economic pressure, may also lead to drug abuse in women. The combination of being devalued because she is a woman, a racial or ethnic minority, and poor has also been posited as the underlying cause for abuse by some women. (P. 216)

Bush-Baskette (1999) concludes that current drug policies, such as mandatory minimums, are an expensive way to reduce drug trafficking as they target those individuals relegated to the bottom of the drug business hierarchy, particularly women.

Faith (1999) laments that the profile of women in prison in Canada reflects that of women imprisoned elsewhere in the world (e.g. young, minority and under 35 years of age) (Faith 1999). Here, too, the women behind bars are mostly single, drug addicted mothers who have a history of sexual abuse (Faith 1999). Furthermore, Faith (1999) examines women's imprisonment in Canada during the 1990s and exposes numerous troubling facts. Prior to the 1995 release of an unauthorized videotape which exposed abuses against eight female inmates in segregation cells in 1994 at one Canadian correctional facility, other questionable acts of law-breaking by the correctional service were also noted. Additionally, serious violations of women's rights in prison were uncovered. For example, at the Prison for Women (P4W), located in Kingston, Ontario, physical structure and custodial practices date back to its 1934 inception (Faith 1999). Fortunately, P4W replaced the practice of confining women in small, dark, cold, bug-ridden attics and cells in Canada's men's prisons. But, unfortunately, P4W offered little solace for women prisoners. Female inmates were treated to a regular diet of random strip-searches in cells, body cavity searches, hand shackles, leg irons, and physical and verbal assaults (Faith 1999). Finally, at the urging of feminists, the Canadian Human Rights Commission agreed that the physical structure and custodial practices at P4W were indeed discriminatory.

In some provinces and territories, First Nations women represent 100% of the jail population. A profile of Canadian prisoners reveals that First Nations women total 30% of Canadian federal prisoners, while they make up only 4% of the overall population (Faith 1999). First Nations women comprise almost 19% of federal women prisoners in Canada. Additionally, nearly 12% are black women, while 3% are Asian (Faith 1999). Similarly, the women are in prison for a multitude of crimes such as petty theft, chronic larceny (shoplifting), writing bad or fraudulent checks, and welfare fraud. The 1980s ushered in a period of substantial increase in the numbers of African American and Caribbean women incarcerated for drug trafficking with regard to marijuana (Faith 1999). The author sums up the women's crimes with the following:

> The crimes of women in Canadian prisons run the gamut. Women commit up to 15 percent of all violent assaults and homicide. They are convicted of 14 percent of cocaine charges and over two-thirds of charges involving pharmaceuticals. (Faith 1999: 110)

Thus, researchers like Holsinger suggest that uncovering the sexism, classism, victimization, and racism experienced by female offenders is critical to attempts to theorize about them (Holsinger (2000). Although much research has been done in relation to women's crime, there are gaps which support further examination of how race, gender, and class intersect in these systems. How incarcerated black women understand crime, themselves, and others could inform theory, research, practice, and policy.

According to Gaarder and Belknap (2002), physical abuse, sexual abuse, and child neglect are defining features of the lives of too many female offenders and these traumas are all often related to one's likelihood of committing crimes. However, what I find missing in the literature on women's pathways to crime are women's attributions for their own behavior. This would contribute to a theoretical understanding of attributions concerning crime by women offenders. I

argue, as others have, that an understanding of women's crime attributions has implications for the futures of women offenders.

Furthermore, I am interested in the behavioral consequences of causal attributions. Certainly some behavioral consequences of interest to criminologists (e.g., recidivism) cannot be investigated in this study; however, many consequences of causal attributions have been examined in prior research that can be studied in this investigation. These include low self-esteem, responsibility, diminished motivation (defeatism), and expectations for the future (optimism) (Forsyth 1980; Brickman 1982; Bae and Crittenden 1983; Weiner 1986; and Nair 1994). Theoretically this study fills a gap in social psychology in that it explores gendered and racialized attributions about crime. This theoretical typology generates insights regarding women offenders' perceptions of self and other.

Dodge's (2002) institutional history of Illinois women prisons provides a conceptual framework of the social construction of prosecution and criminality. Dodge covers a 137 year-long period of patterns and responses to women's criminality in *Whores and Thieves of the Worst Kind: A Study of Women, Crime, and Prisons, 1835-2000.* Dodge analyzed primary data from the Joliet Women's Prison and Illinois State Reformatory for Women at Dwight. Additionally, Dodge (2002) analyzed prison files, superintendents' statistical reports, pardon petitions, convict register books, and interviews. Particularly, Dodge was interested in understanding the ways in which gender, race, and class intersect in the criminal justice system. In fact, throughout history, women have not only been held responsible for the laws they violate, they have also been punished for perceived violations of "proper femininity," and "respectable womanhood." Dodge (2002) covers the gamut of women's experiences of the criminal justice system. In the 1990s, there were anywhere from 300 to 350 women sentenced to federal prison in Canada.

Johnson (2003), in her book *Inner Lives: Voices of African American Women in Prison,* interviewed over 100 current and formerly incarcerated African

American women about their lives and their experiences in U.S. prisons and jails. Johnson (2003) writes:

> Invariably their traumas resulted from family dysfunction; any inability or disinclination to make wise decisions about friends and intimate companions; the realities and perceptions of limited or nonexistent life choices; and a lack of alternatives for productive, fulfilling and economically viable lives. (P. 14)

These findings suggest that it is necessary to separate the myths and stereotypes of criminality among African American women from their real-life experiences. According to Johnson (2003), structural gender, race, and class oppression further hamper African American women's ability to achieve or become productive members of society. Johnson (2003) sums this up with the following statement:

> A black woman's entry into the prison system is characterized by her struggles with poverty, illiteracy, substance abuse, mental illness, childhood sexual abuse, and an intricate web of life-threatening physical, psychological, and social problems. (P. 2)

The "pathways to crime" approach to understanding the etiology of female offending has been examined by feminist and criminologists with interesting and some times conflicting results. In "From Victims to Survivors to Offenders: Women's Routes of Entry and Immersion Into Street Crime," Gilfus (2006) explores how women enter into criminal activity via 20 in-depth life history interviews (12 white and 8 black) with incarcerated women. According to Gilfus (2006), women's criminality differs markedly from men's criminality (Gilfus 2006). Gilfus' (2006) study illustrates the criminalization of girls' survival strategies, chronicling how female offenders begin their criminal careers. The life history is a text or document that develops out of a collaboration involving the consciousness of the investigator as well as the informant. The author organizes the life history interviews around the dominant childhood themes of violence, loss, and neglect and a sub-theme of caring for others while the predominant

adolescent themes included survival strategies and escape. This study develops a typology of women offenders from the perspective of female inmates.

Specifically, 13 of the women reported a history of childhood sexual abuse and the early childhood sexual abuse experiences of 5 of these women completely mastered their lives (Gilfus 2006). Furthermore, 10 additional women reported multiple forms of abuse and neglect such as parental alcoholism/substance dependence, incest, sexual and physical abuse, and neglected basic needs (Gilfus 2006). Ironically, 13 of the 20 women reported running away as their initial foray into delinquent behavior, while 17 women worked as juvenile prostitutes (Gilfus 2006). Indeed, Gilfus (2006) found that adolescence themes of violence were characterized by survival strategies and escape. For instance, the onset of delinquent drug use, truancy, and stealing was closely associated with early runaway attempts. This work elaborates upon these preliminarily thematic conceptualizations offered by Gilfus by developing a typology of women's crime attributions. Gilfus (2006) summarizes her themes of the women's transition from childhood to adulthood:

> Patterns of repeated victimization, drug addiction, street work, relationships with men involved in street crime, and the demands of mothering are the themes that mark their transitions from childhood to adulthood. The survival strategies which had helped the women escape from early victimization contributed to revictimization and their adult status as offenders. (P. 9)

Gaarder and Belknap (2002) term this process "blurred boundaries." The authors examined the life histories of 22 girls adjudicated as adults and confined in a Midwest adult women's prison. Specifically, Gaarder and Belknap (2002) argue that gender, race/ethnicity, class, and sexual orientation are all important factors to be considered in girls' and women's lawbreaking. According to Gaarder and Belknap (2002), these complex offenders should instead be viewed on a continuum from "victim" to "offender."

The aforementioned discussion leads researchers like Beth Richie (1996) to conclude that some women are "lured into compromising acts" and Meda Chesney-Lind (1997) to argue that girls' and women's survival strategies are all too often criminalized by our criminal justice system. In short, these women are both victims and perpetrators of crime.

The following research questions guided the research:

Q1: Do black female offenders make more internal or external attributions in regard to their crimes?

Q2: Do black female offenders make more internal or external attributions in regard to other black women's crimes?

Q3: Do black female offenders make more internal or external attributions in regard to white women's crimes?

Q4: Do black female offenders make more internal or external attributions in regard to other women's crimes?

Q5: Do black female offenders make more internal or external attributions in regard to black men's crimes?

Q6: What are black female offenders' hopes and dreams for their future?

For this study, literature regarding women offenders provided a context for examining the female criminality. Rather than characterizing all women offenders' criminality in much the same way, I draw upon black female offenders' perceptions of what causes crime. Notably, the bulk of research on pathways does not address the women's perceptions of why they ended up incarcerated in the first place.

CHAPTER THREE:
IMPORTANCE OF PERCEPTIONS AND ATTRIBUTIONS

This study was guided by a sociological theory of attributions built on assumptions about the importance of perceptions and beliefs. In this chapter I will discuss in detail two important research studies regarding inmates' views and perceptions of what causes crime. Additionally, I will present my theoretical framework and an overview of the way in which judgments of crimes and criminals are affected by the race and gender of those being judged. I conclude with the concept of locus of control and differences among students, inmates, and the general public's perceptions of the factors responsible for the outcome of an event.

Charles Horton Cooley (1909) observed that our perceptions of what others think of us are more important in determining our self-concepts than what others really think. Shortly thereafter, Thomas and Thomas (1928: 14) stated that, "If men define situations as real, they are real in their consequences." Indeed, individuals' beliefs or subjective perceptions are likely to be influenced by both dimensions of these perceptions, as people simultaneously compartmentalize different beliefs but do not strive for attitudinal consistency (Kluegal and Smith 1986). Tischler (2004) summarizes these insights with the following statement:

> [T]hat although our perceptions are not always correct, what we believe is more important in determining our behavior than is what is real. If we can

understand the ways in which people perceive reality, then we can begin to understand their behavior. (P. 89)

The theory of perceptions and attributions is used to understand black women offenders. For multiple reasons, the criminal justice system in the United States is under intense public scrutiny. One reason is that the United States has the highest rate of incarceration in the entire world. In fact, the 1980s and 1990s ushered in a period of substantial increase in both federal and state inmate populations. Currently, there are 2.3 million individuals behind bars in the U.S. (Pew Research Center 2008). The discipline of criminology has attempted to ask and answer the most important questions about the nature and causes of crime. The majority of these studies were based on surveys of public or student perceptions. Some of these studies have focused on offender's perceptions of crime, but most of these have involved male inmates. Few studies have focused on women's perceptions of the origins of crime, while no study has focused on black women offender's perceptions of what causes crime. This is not surprising considering the fact that female offenders did not become the focus of research until the 1960s, and much of this research ignored perceptions held by offenders in favor of studies of the "objective" causes of crime such as demographic background and social context.

The goal of this study was to uncover black female offenders' perceptions of crime causality and hopes and dreams for their future via a qualitative methodology focusing on black female offenders. Additionally, the women were asked about their perceptions of the effects of crime on their future lives. This research expands on two earlier studies. First, Mathis and Rayman (1972) studied male prison inmates' views and perceptions on what causes crime. The authors found that inmates identify external, environmental factors as one of the primary causes of crime. Second, Gillespie and Galliher (1972) highlight the importance of male inmates' definition of the impact of prison on their prospects for the future. Although the authors focused on age differences among inmates,

something that cannot be systematically investigated in my work, their study is relevant to mine because it draws attention to the consequences of inmates' definitions of themselves and their situations for their optimism about the future.

By interviewing African American offenders and examining their perceptions on what causes crime and the relationships of those perceptions to offenders' plans for their future, important information can be obtained concerning the ways in which these female offenders understand crime, themselves, and others. This information can be used to make recommendations to researchers, politicians, policy makers, and the public: all of whom represent important stakeholders in this matter. Furthermore, this study may be used to address important feminist criminal justice concerns about the orientations of women offenders and the potential impact of these orientations on the future lives of those women.

Theory: The Social Psychology of Causal Attributions

Stated simply, attribution theory focuses on how people explain behavior. Specifically, this study draws upon the social psychological approach known as attribution theory (Heider 1958; Ross and Nisbett 1991) and on the sociological work concerned with how people account for their behaviors, especially behaviors unlikely to be approved in their society (Scott and Lyman 1968). According to Smith and Kluegal (1979), attributions are determined largely by the individual's perceptions and other attitudes rather than by concrete social position. In fact, attributions have been shown to have important consequences for politically relevant attitudes and policy preferences. Central to the theoretical framework used in this research are the distinctions between perceiver and perceived, between perceived others who are similar and those who are dissimilar, between external and internal loci of control, and between positive and negative consequences of attributions.

Causal Relationships of Crime. Causal interpretations about crime have been found to differ between the perceiver of crime and the perceived criminal.

Perceivers include the mass media, general public, including undergraduates, and authorities in the criminal justice system. Via the media, the public is constantly being bombarded by criminal behavior (Surette 1992). Considering this fact, attributions concerning crime by the mass media are particularly important. According to Monahan (2000), in her study of the attributions journalists give for violence against women, individualistic attributions were more common than social structural ones and these attributions have changed significantly over time. When causal relationships of crime are advanced in the media the individual is normally the focus. Causes are generally located in individual choices and deficiencies while references to structural conditions that might act as an impetus to criminal behavior are absent (Surette 1992). Furthermore, Meyers (1997) contends that when explaining violence against women, the news media all too frequently blame the victim. In other words, a woman being held responsible for her rape. In addition, violence against women is more often characterized by the news media as the result of individual choices and/or pathology rather than social organization.

Given these characterizations of the American mass media, it is not surprising that some researchers (e.g., Na and Loftus 1998) have found that American students make fewer external attributions for crimes than their Korean counterparts. Some evidence has also appeared indicating that, at least for the crime of rape, Americans are even more likely to make internal attributions for female victims than for male victims (Schneider, Ee, and Aronson 1994). Within the general public, this tendency to attribute crime to characteristics of the individual has been found to be associated with religiosity. Grasmick and McGill (1994) report that individuals espousing conservative religious beliefs had a tendency to attribute crime to dispositional factors, such as the offender's character, rather than to unfortunate or unjust environmental influences.

Attributions concerning crime by officials of the criminal justice system (judges, jurors, parole boards, wardens, prison staff, police, and police trainees) suggest that explanations and punishments for crime are generally heavily

influenced by a focus on the personal characteristics of accused criminals, such as prior criminal record (Albonetti 1991), race and ethnicity (Bridges and Steen 1998; McMorris 2001), drunkenness and bad character (Kalven and Zeisel 1966). The effects of race and ethnicity upon these judgments have attracted considerable attention and racial dissensus. McMorris (2001:92), for example, reports that 68% of blacks agreed and 70% of whites disagreed with the statement, "Police officers unfairly target minorities for arrest." Consistent with the perception of the black volunteers, Jones (1995) found that race had a direct effect on the overall punishment given to defendants, with blacks being punished more severely than whites, regardless of the crime.

Whereas those asked to judge criminals tend to focus on background characteristics and internal causes of crime, the research literature suggest that the criminals themselves have a somewhat different view. The explanations the latter give seem to vary depending on the crime. Child molesters, for example, seem to be far more likely to attribute their crime to internal and uncontrollable causes than do property offenders or other violent offenders, such as rapists (McKay, Chapman, and Long 1996). Studies done in New Zealand, Canada, and the United States all support the finding that prisoners and probationers, other than child molesters, tend to make more external than internal attributions for their present predicament (Lightfoot and Hodgins 1988; McKay et al. 1996).

The Ins and Outs of Crime and Corrections (1972) is often referenced in studies of inmate's perception of crime causation. This study, conducted by Frank O. Mathis and Martin B. Rayman compared the public's and inmates' perceptions of crime causation. The authors systematically compared responses from the Louis Harris, Inc., 1968 study of public perceptions to a sample of 919 inmates in a Maryland Correction Training Center. Overwhelmingly, inmates located the causes of crime in "bad environment," drugs, unemployment, and poverty, while the public sees crime as the result of ineffectiveness of parental control over their children's bad behaviors.

These findings about the distinction between perceiver and perceived are consistent with the perceptual tendency social psychologists have labeled, "the fundamental attribution error," a term that refers to the tendency to discount the situation when explaining other people's behavior (Ross and Nisbett 1991). A large literature, studying attributions for many forms of behavior other than crime, has found that individuals most often explain their own behavior in terms of the situation but hold others personally responsible for their behaviors. Thus, individuals usually underestimate the situation when explaining others' behavior and overestimate the situation when explaining their own behavior.

The major exception to this finding in the literature concerned with crime seems to be child sex offenders. Although they have been found to make more internal attributions for their crimes than other criminals, Beling, Hudson, and Ward (2001) point out that their internal attributions are often tied to perceptions of external causality:

> [W]hile child sex offenders defined the cause of their sexual arousal and offending as external (i.e., children's bodies), they reported the effect of such stimuli on their arousal patterns as being internal. In other words while they perceived the stimulus as external (children's bodies) the causal mechanism (sexual arousal) was "owned" that is internal. (P. 63)

This analysis suggests that child sex offenders, like other criminals, may be more likely than observers of them and their crime to blame external conditions for what they have done.

Offender-Based Research

Offender's perceptions of punishment, health care, prison education, deterrence, public legal education, and interpersonal relationships have been examined by researchers (Wood and Grasmick 1999; Zhang, Messner, and Lu 1999; Piquero and Rengert 1999; Maxwell 2000; Young 2000; Osberg 1986; Decker, Wright, and Logie 1993; McCormack, Hudson, and Ward 2002; and

Petrocelli, Calhoun, and Glaser 2003). According to Piquero and Rengert (1999), attempts to reduce the incidence of crime will only be effective in as far as we understand how offenders view and perceive crime as well as its causes.

Wood and Grasmick (1999) recognize the impact of offenders' perceptions in their study of criminal sanctions. Specifically, the authors studied male and female offenders' perceptions of the severity of alternative sanctions to prison. The authors studied 415 respondents (181 men, 224 women, and 10 who did not report their gender) serving time in Oklahoma correctional centers. Offenders were asked to rate the severity of the following punishments on a continuum: county jail, boot camp, electronic monitoring, regular probation, community service, day reporting, ISP, halfway house, prison, and intermittent incarceration. Results showed gender differences in "punishment equivalencies." Female offenders were more willing than men to participate in most alternative sanction programs. Although both groups show a dislike of county jail, women register lower refusal rates with regard to boot camp, regular probation, community service, ISP, intermittent incarceration, and day fines. Wood and Grasmick (1999) note the following characteristics of women's perceptions of certain alternatives:

> Women's greater amenability to alternatives holds true except for electronic monitoring and halfway house, in which women are less willing to participate. This discrepancy may be a function of the restrictions associated with the sanctions. For example, the description of halfway house presented to the inmates states that no visitors are allowed; such a restriction would preclude mothers from living with their children or bringing them to the house. In the case of electronic monitoring, an incapacitating punishment designed to restrict physical movement, women may demand greater flexibility in their schedules to attend to children's needs. (P. 36)

Zhang, Messner, and Lu (1999) evaluated the policy of public legal education in China in 1991. The authors surveyed offenders incarcerated in correctional institutions in Tianjin about their perceptions of the legitimacy of

official sanctions and crime commission. Public legal education was pioneered by the Chinese government in 1979 and takes place at all levels of Chinese society—national, provincial, local, and neighborhood—through media, posters, pamphlets, and education programs. The authors summarize their study with the following statement:

> We reason that if public legal education is in fact meeting its intended objective of legitimating the law (through both normative and utilitarian appeals), then exposure to such education should increase the likelihood that legal punishments are perceived to be fair and just. We therefore propose the following specific research hypothesis concerning those who have direct experience with legal punishment—incarcerated offenders: offenders are more likely to perceive their punishments as legitimate to the extent that their neighborhood conducts public legal education activities. (Zhang, et al., 1999: 438)

Not surprisingly, 48% of respondents perceived that their punishments were based on clear evidence and correct determination of the nature of their crime, while 69.6% reported that their punishments were fitting. In regard to legal education in the neighborhood, only 10.2% of respondents reported routine legal education in their neighborhoods, while 65 percent reported no such activities and 24.8% reported such activities sometimes. Zhang et al., (1999) summarize these findings with the following statement:

> This distribution indicates that although the Chinese authorities have attempted to implement the strategy of public legal education, such activities are not prevalent everywhere. Of course, these proportions are based on an inmate sample. Offenders might be drawn disproportionately from neighborhoods that lacked legal education. (P. 444)

As the authors hypothesized, public legal education increased the probability of perceptions of sanction fairness.

Moreover, Piquero and Rengert (1999) studied the decision-making process of fifteen active male residential burglars in the Philadelphia area. The authors examined how a nonrandom sample of offenders evaluated the probability

of gains and losses into a judgment about the feasibility of crime opportunities. Respondents were asked to evaluate a series of opportunities along four dimensions: (1) the probability of a successful crime, (2) the amount of money to be obtained if the burglar is successful, (3) the probability of capture, and (4) the penalty if the burglar is caught. Piquero and Rengert (1999) summarize their methods with the following statement:

> Following Carroll (1978), we used 10, 30, or 80 percent for the probability of gain (success at committing the crime). For the probability of punishment, we used 5, 15, or 40 percent. For the amount of money to be gained, we used $100, $1,000, or $10,000. Finally, for the severity of punishment, we used probation, six months in prison, or 24 months in prison. With some minor exceptions, these levels correspond very closely to those in work by Decker et al., (1993) in their study of St. Louis burglars. (P. 459)

The authors found that the burglars operated as expected from deterrence theory, in that, when the amount and probability of gain increase, so does the offender's probability of engaging in burglary. Additionally, the relationship between probability of gain and probability of burglary was linear and statistically significant. Burglars were more likely to report high probabilities of burglary at high levels of gain and high probabilities of gain. In other words, when probability of punishment was at its lowest, the probability of burglary was at its highest (Piquero and Rengert 1999).

Maxwell (2000) examined the effects of sanction threats within the context of retention in court-mandated treatment programs. Specifically, the author investigated how offenders perceive sanction threat. Maxwell (2000) looked at the effects of sanction threats on 720 offenders in three residential therapeutic communities in the northeast United States. Maxwell (2000) summarizes the parameters of her study with the following statement:

> Drawing from relevant concepts in deterrence, this article examined two measures of sanction threat, legal status and legal pressure, and their

effects on lengths of stays in treatment among legally referred offenders. (P. 559)

Maxwell (2000) found that although many factors influence retention, legal status and legal pressure had the most significant effect. Thus, the defendants' legal status did not affect their perceptions of threat and greater perceived threat increased retention.

Similarly, Young (2000), in her study of women's perceptions of health care provision in prison, found an overlap between positive and negative perceptions of care. Fifteen female inmates in a northwestern state prison shared their experiences by answering a series of open-ended questions in regard to the health needs they had in the past 4 to 6 months, what health services they used, and how they felt about the care and treatment received. It appears that women do not hold exclusively positive or negative views about the care and treatment they receive behind bars. Fourteen of the women described more than one form of inadequate care, while only one woman described no instances of inadequate care. Thirteen women provided examples of partial care, ten women sited instances of no care and delayed care, and eight women described their experience with misdirected care. Although descriptions of inadequate care were numerous, there were also stories of adequate care. Young (2000: 230) summarizes the characteristics of women's perceptions of care and treatment: "Examples of inadequate care are described by 14 women and nonempathetic treatment by all 15. Examples of adequate care are described by 11 women and empathetic treatment by 10."

Osberg (1986) studied inmates' perceptions of how studying psychology had influenced them. The author surveyed a sample of 22 inmates at the Attica Correctional Facility (a maximum security prison in Attica, New York) to explore whether the introductory psychology course produced important changes in the inmates. Some perceived gain was found, even in response to the sensitive question of whether inmates had developed a better understanding of why they

had committed their crimes. Osberg (1986) summarizes this finding with the following statement:

> Sixty-four percent either agreed (32%) or strongly agreed (32%) that they had "gained a better understanding of the circumstances that led to (their) imprisonment through the study of psychology. (P. 18)

Decker, Wright, and Logie (1993), in their study of perceptual deterrence, note that perceptions of risk and reward effect willingness to offend. Decker et al. examined the subjective process of deterrence for a sample of 48 active residential burglars and 40 nonoffenders. The authors found that risk of being caught and the prospect of increased gain significantly influenced the burglars' decision making. The authors sum this up with the following statement:

> What mattered was that the offenders were given the possibility of gaining more than they originally had thought. To put this result another way, an offender who is offered the possibility of stealing $5,000 is no more willing to offend than someone who is offered $500. However, if someone is first offered $200, he or she will be more willing to offend if then offered $500. It is an interesting finding in that it demonstrates the power of relative as opposed to absolute levels of potential gain. (Decker, Wright, and Logie (1993: 143)

McCormack, Hudson, and Ward (2002) recognize the impact of offenders early life experiences, particularly those aspects associated with their offense-related problems. The authors examined sexual offenders' perceptions of their early interpersonal relationships using grounded theory and the attachment perspective. Study participants were comprised of 147 men, 55 who had offended sexually against children, 30 who had offended sexually against adult women, 32 with violent offenses, and 30 incarcerated for neither sexual nor violent offenses. McCormack et al. (2002) found that the overwhelming majority of the offenders described their interactions with caregivers as involving high amounts of neglect and rejection and low levels of supervision, discipline, and consistency. In fact, early interpersonal experiences of offenders were mostly negative, while rapist

and violent offenders described the most negative of these experiences, typically involving fathers. Furthermore, McCormack et al., (2002) found that negative early interpersonal experiences are characteristic of violent and nonviolent offenders and are not specific to sexual offenders.

Petrocelli, Calhoun, and Glaser (2003) investigated the relationship between African American juvenile offenders' family functioning characteristics and the quality of their mother-daughter relationships. The authors examined the perceptions of 76 juvenile offenders, aged 13 to 17, who participated in counseling and guidance services through a juvenile counseling and assessment program. Petrocelli et al., (2003) utilized the McMaster Family Assessment Device (FAD), a 60-item, self-report instrument which measures seven dimensions of family functioning: problem solving, communication, roles, affective responsiveness, affective involvement, behavior control, and general functioning. The authors found that although all of the family functioning constructs measured, with the exception of communication, were positively related to the quality of the mother-daughter relationship, only general family functioning contributed significantly to that relationship.

Gardstrom (1999) investigated music listening patterns and the perceived influence of listening on young offenders' fantasies and behavior. This study examined 106 male felony offenders' (age 12 to 17) perceptions of the relationship between exposure to music and their criminal behavior. Findings indicate that most respondents placed confidence in reflection-rejection theory, which argues that music is perceived as a mirror of the adolescents' lives and not a causational factor of their behavior. Moreover, respondents expressed belief in drive reduction theory, which posits that music acts as an expressive vehicle, thereby reducing the probability of emotional and physical explosion. In fact, two-thirds (72%) believed that exposure to music had some effect—mostly positive—on their level of arousal or mood. Respondents also cited excitation-transfer theory, which states residual physiological arousal affects subsequent behavior.

Racialized Attributions About Crime. Although research guided by attribution theory has revealed a major distinction between attributions for self and others, it has not paid much attention to the fact that "others" may be more or less similar to one's self. Among the bases for similarity and dissimilarity that have been ignored, the one that is crucial to this work is the major social distinction of race. In contrast to attribution theorists, criminologists have been centrally concerned with the way in which judgments of crimes and criminals are affected by the race of those being judged.

Unfortunately, for present purposes, most of this concern has been focused on male criminals. Nevertheless, the research generated by this concern is useful for demonstrating the ways in which race of others affects the ways in which those others are perceived and judged. As noted above, Jones (1995) found that race had a direct effect on the overall punishment given to defendants, with black defendants being punished more severely than whites. Similarly, Harrison and Esqueda (2001) found that black males involved in interpersonal violence were perceived more negatively than similarly situated white males. Even in situations in which domestic violence victims drink alcoholic beverages before the assault, black victims were attributed more responsibility for the assault than their white counterparts:

> [T]he effect of victim drinking on domestic violence attributions is especially troublesome for black domestic violence victims because our research found that perceivers blame and derogate them more than their white counterparts. (Harrison and Esqueda 2000: 1053)

The aforementioned discussion leads Harrison and Esqueda (2001) to purport that stereotypes about blacks as aggressive and prone to violence negatively influence judgments about blacks, particularly among white perceivers. Harrison and Esqueda (2001), in their study of race stereotypes and perceptions about black males involved in interpersonal violence among college students, purport that because perceptually vague and ambiguous behaviors of black men

are perceived more negatively and threatening than the similar behavior of white men, the legal system may not treat black and white males equitably.

Sommers and Ellsworth (2000) note that the race of the perceiver also has effects on the judgments of black offenders. According to these authors, white mock jurors judged the black defendant more guilty, aggressive, and violent than the white defendant. Moreover, Sommers and Ellsworth (2000) found that black mock jurors' perceptions demonstrated same-race leniency. Sommers and Ellsworth (2000) thus conclude that racial issues are very salient in the minds of black jurors in interracial cases with black defendants.

The fact that race is salient in the mind of blacks suggests the possibility that black women offenders might judge the crimes of other black offenders differently from the crimes of white offenders. To date, no research seems to have appeared on this topic, but the findings of research concerned with race and male crime suggest the likelihood that the distinction that attribution theorists make between attributions concerning self and others is complicated by the race of the others.

Locus of Control for Crimes

The concept of locus of control refers to the perception of the factors responsible for the outcome of an event. According to Weiner (1974), a leading attribution theorist, perceptions about locus of control among the general public can be divided into two types: internal (personal) factors and external (environmental) causes. As noted above, this distinction has often been used in studies of perceptions of crime. Internal locus of control refers to the belief that one controls one's destiny. Researchers have documented positive aspects of internal locus of control (e.g., higher earnings, dealing with marital conflict, school success, practicing birth control, smoking cessation, obeying seatbelt laws, and delayed gratification to achieve long-term goals) (Lefcourt 1972; Findley and Cooper 1986). In contrast, external locus of control refers to the perception that

one's fate is determined by chance or forces outside of one's ability to control (Rotter 1973).

An important aspect to be considered in regard to the locus of control dimension is the American cultural narrative. The American cultural narrative is the vehicle by which the American identity is constructed daily by Americans. The American cultural narrative rests on individualism, morality and personal responsibility. Jackman (1994) sums this up with the following statement:

> The centrality to Western ethics of the associated norms of individual liberty, achievement based on individual merit, and "free" competition has been observed by such disparate social analysts as Edmund Burke ([1775] 11954), Alexis de Tocqueville ([1850] 1969), Karl Marx ([1857-1858] 1971, 70-73, 128-131), and Max Weber (1946b; [1930] 1958). (P. 222)

Thus, individualism is the foundation of the American cultural narrative and affects judgments of self and others and encourages the idea of internal locus of control for both self and others.

For instance, Babcock and Laschever (2003), in their study of gender and negotiation, grapple with the consequences of gendered differences in perceptions. These authors point out that the belief that control over your life ultimately rests with others can have a great impact on your life experiences. Babcock and Laschever (2003) found that women's locus of control is different from men's. These authors attribute this fact to women's continuing lack of political and economic power, which results in much of the control over women's lives remaining in the hands of others. Babcock and Laschever (2003) sum this up with the following statement:

> Battling for other forms of control—such as the right to own property, make free and informed choices about procreation and birth control, and work in any profession of their choosing—occupied women in Western culture for much of the twentieth century. (P. 24).

Furthermore, despite the evidence for positive consequences of an internal locus of control, most of these consequences have been found to result from internal attributions for personal success. When people fail and use internal attributions to explain that failure, it is less certain whether positive outcomes will result. On the one hand, a person may take personal responsibility for a failure and vow to do better in the future. On the other hand, a person may accept blame and become mired in guilt and despair. As suggested in the following section of this work, one of the purposes of the research was to determine what kinds of outcomes (i.e., plans for the future) are associated with different kinds of attributions.

The internal-external distinction is not only made in judgments of one's own behaviors but also, as indicated earlier, in judgments of the behaviors of others. Thus, the distinction is linked to the sociological concern with the ways in which individualism affects judgments of other people. According to Jackman (1994) the ideology of individualism is ubiquitous in American culture today. This dominant ideology purports that all individuals have the right to live as they so choose and must be responsible for their own fate. Jackman (1994) sums up the implications of American individualism with the following:

> However, the central issue has been whether the individual explains group differences in a way that lays the blame for those differences on biases in the social structure (thereby facilitating support for affirmative policy interventions) or on the subordinate group itself (thereby alleviating the dominant group of responsibility for affirmative policy interventions). (P. 308)

Although Jackman's focus is on how dominant groups judge minorities, her study also raises the question of how minority groups judge others of the same and different racial identity. In other words, will black female inmates make more or fewer internal attributions in regard to self, other black offenders, white and other offenders?

Male locus of control is consistent with the American cultural narrative of individualism, personal responsibility, and personal success. Thus, affluent white males are the epitome of this dominant American cultural ideology, possessing the "right" race, gender, and class according to this cultural narrative. In contrast, women continue to face an uphill challenge in pursuit of personal, social, economic, and political power and are more likely to have an external perception of locus of control. According to Babcock and Laschever (2003), the basic reality of gender bias and inequality ensures that control over women's lives remains in the hands of others. James and Sharpley-Whiting sum this up with the following statement:

> One reason to focus on the state, rather than on an essentialized male entity, is that the state wields considerable dominance over the lives of non-elite women. The government intrudes upon and regulates the lives of poor or incarcerated females more than bourgeois and non-imprisoned ones, determining their material well-being and physical mobility, and affecting their psychological and emotional health." (James and Sharpley-Whiting 2000)

Likewise, Babcock and Laschever (2003) purport that women are not alone in their perception that others control their lives, as many cultural and ethnic minorities also see themselves excluded from the U.S. political and economic power base. Consequently, Collins (1998) advances the call for "intersectionality," which appropriately emphasizes the way in which African American women and other social groups are positioned within asymmetrical and unjust power relations. Thus, the question arises: How do African American female inmates situate themselves in relation to the American cultural narrative and locus of control?

Related to the internal-external distinction central to attribution theory is the distinction between explanations and justifications developed by Scott and Lyman (1968) and applied to criminal behaviors by Felson and Ribner (1981) who report that (male) inmates use more justifications than excuses for their

criminal actions. An excuse is defined as an inmate's claim of low personal causation while a justification is defined as a norm other than the one that was violated. Dutton (1986), in his study of wife abuse, also classified attributions into categories of excuses and justification. Those who made excuses accepted that the assault was wrong, while denying personal responsibility. Those who made justifications accepted personal responsibility, all along denying that the act was wrong. Dutton found that twenty-one percent of perpetrators of wife abuse excused the assault, while seventy-nine percent accepted personal responsibility but justified it by either blaming the victim or discounting the behavior as uncontrollable arousal or subgroup norms. This research suggests that internal attributions that take the form of personal responsibility may have different consequences depending on whether they are classified as excuses versus justifications.

Not only is it necessary to look at the interrelationships among internal and external attributions, but it is also likely that some explanations for crime cannot easily be categorized into internal vs. external categories. Drug use is one that comes to mind. Although drug use may have originated in external causes, a person who is addicted may consider drug use to be a personal or internal cause of subsequent behaviors. In my research, I was sensitive to the complexities of the causes that women gave for their crimes and those of other women. Additionally, I tried to incorporate some of that complexity in the typology of women offenders I developed.

One additional complication with regard to locus of control is the possibility that attributions may be gendered. Frieze, Bernard, Whitley, Hanusa, McHugh, and Valle (1978) argue that attributional styles vary by gender. Furthermore, Chandler, Shama, and Wolf (1983) suggest that gender affects attributional style. Crittenden (1991) found that the typical male attributional pattern was self-enhancing and internal. In contrast, the typical female attributional style is more self-effacing. These findings are consistent with Frieze et al. (1978). According to these authors, women tend to attribute their successes

to external factors and their failures to internal ones and this tendency is particularly likely in achievement settings. Although this line of research suggests that some of the findings about internal vs. external attributions of men summarized in this work may not apply to women, the notion that women are less likely than men to make internal attributions for their own successes has been challenged by Bank (1995) whose longitudinal study of students' success at a state university produced the opposite result. Bank also found that, contrary to some earlier claims by other researchers, men were more likely than women to attribute their successes to uncontrollable, external circumstances, such as luck.

Unfortunately, Bank did not study attributions for failures such as being found guilty of a crime, but my research investigates whether women are more likely to use internal or external explanations for their own and others' crimes and incarcerations. Researchers have documented at least one kind of behavior in the prison context itself for which female prisoners are likely to make an attribution external to themselves and to other female inmates. In their qualitative study of female inmates' perspectives on sexual abuse by correctional personnel, Calhoun and Coleman (2002) found that the female inmates perceived correction officers as ultimately responsible for any sexual contact that occurs between inmates and staff. These authors sum this up with the following statement:

> While the women acknowledged that sometimes inmates initiated the sexual contact, they also believed that responsibility for following through on the sexual contact was always the responsibility of the correctional employee. (Calhoun and Coleman 2002: 111)

This research attempts to determine whether this tendency to make external attributions also extends to the crimes women committed prior to incarceration.

Consequences of Attributions About Crime

Attribution is a three-pronged process beginning with social perception, progressing through causal judgment and social inference, and ending with

behavioral consequences (Crittenden 1991). Because of limitations of time and resources, some behavioral consequences of interest to criminologists (e.g., recidivism) cannot be investigated in this study. Nevertheless, many consequences of causal attributions have been examined in prior research that can be studied in this investigation and that have implications for the futures of the women in my study. These include low self-esteem, responsibility, diminished motivation (defeatism), and expectations for the future (optimism) (Forsyth 1980; Brickman 1982; Bae and Crittenden 1983; Weiner 1986; and Nair 1994).

Drawing upon earlier work by Brickman (1982), Nair (1994) provides a particularly useful way of thinking about attributions of prisoners and their implications for the future. Brickman described four attributional models of coping and helping in client-counselor relationships based on the attributions clients made, first, for their past behavior and current predicament and, second, for changes in the future: the moralistic model (internal-internal), the medical model (external-external), the incompetent muddler model (internal-external), and mastery of adversity model (external-internal). Nair studied prisoners and probationers in Singapore to determine which of the models best described their perceptions of their personal situations. She reports that:

> Results of the present study indicate that perception of the prisoners and probationers in Singapore is dominated by two kinds of attribution: Responsibility for present status (i.e., who led them to their present plight?) and responsibility for change (i.e., who will help next?). The prisoners clearly blamed the external sources for their present status. They cited other people and "life" as being at fault for their predicament. Similarly, they externalized responsibility for change to their present status. They appeared to expect their family and friends to set things right for them. They also reported uncertainty about their own ability to work well. (Nair 1994: 70)

According to Nair, use of the medical model is an abdication of responsibility by the prisoners and probationers and she suggests that, "Perhaps this model may be closely linked to recidivist behavior, as would be the incompetent muddler

model" (Nair, 1994: 66-67). As a possible way to avoid recidivism, she suggests that prisoners be taught to assume responsibility for their future without being blamed for their past (i.e., the mastery of adversity model).

Although neither Nair's study nor mine can test predictions about recidivism, she does make a plausible case for the importance to their future lives and the kinds of attributional models adopted by women prisoners. In the present study, I examined not only the models used by black women offenders to talk about their own past and future, but also the models they use when describing the lives of other black and white women offenders. In summary, inmates predominately cite external (environmental) causes of crime, while students and the general public generally cite internal (personal) causes. Hopefully, this information will not only be of interest to sociologists and criminologists, but will also contribute to the development of strategies and programs for improving the lives of women both in and out of prison.

CHAPTER FOUR:
METHOD AND PROCEDURES

In this chapter, I present the methodological design for this study and then a discussion of the sample characteristics and research setting. Following a discussion of the procedures adhered to throughout the data collection process and an overview of each research question; I present an outline of my analytical framework. I conclude this chapter with a summary of the operational definitions of coding categories developed for the study.

As stated in the previous chapter, this study explored the criminal behavior of black women and its perceived causes from the perspective of black women behind bars. Additionally, this study examined their orientation toward the future and the ways in which those orientations were related to their views of crime. Finally, a preliminary typology of women offenders was developed. Typologies aid in the understanding of the differences in behaviors. Additionally, the typology provides a framework for understanding the diverse types of crime perceptions held by black female offenders.

Sample and Setting

Studies of crime and criminality tend to be focused on "objective" causes of crime and utilize primarily male samples. In contrast, this sample consisted of thirty (30) African American female prisoners between the ages of 19 and 75 years-old at the California Institution for Women (CIW). CIW is a multiple

security level and training institution. Formerly known as Frontera, CIW opened in 1952 and up until 1987 was the only prison in the state of California for female felons. This institution has an annual operating budget of $59,000,000 (Kruttschnitt, Gartner, and Miller 2000). CIW currently employs 394 custody staff members and 262 support staff. The institution has a designed bed space capacity of 1026 and sits on 120 acres of land in Corona, California. CIW serves all custody levels and also functions as a reception/processing center and a special needs facility for pregnant, drug addicted, mentally ill, and HIV-infected women (California Department of Corrections and Rehabilitation 2006).

The women shared the following four (4) objective determining characteristics:

(1) They were women from both offense categories (violent to non-violent offenders) between the ages 19-75.

(2) They were women from different custody levels. The California Institution for Women (CIW) serves all custody levels.

(3) They included both women serving life sentences and women facing the possibility of parole.

(4) Included are newly incarcerated women as well as repeat offenders. Nationally, 65% of female inmates have a criminal justice history.

Thirty (30) African American female inmates participated in this study. The average age of informants at the time of interview was 40 years-old, with the youngest informant being 19 years-old. The oldest informant was 75 years-old. It is important to note that the majority of informants were violent offenders (N=23). The remaining, (N=7), were incarcerated for non-violent offenses. Additionally, over half of the women with violent crime convictions were sentenced to life.

Twelve of the informants have some college education, and another five hold baccalaureate degrees. Six of my informants earned GEDs and two women earned post-baccalaureate degrees (i.e. MA and JD). Keeping in mind that the

majority of these women earned their degrees while incarcerated, 76.6% of informants reported dropping out of school before their senior year. A third of my informants, 33.3% (N=10), were mothers of school age children, with an average of 2.3 children. In eight cases, the children were being cared for by grandparent(s) and in two cases fathers were caring for young children. Finally, in regard to informants' marital status, thirteen (43.3%) were single, eight (26.7%) married, five (16.7%) divorced, two (6.7%) widowed, and two (6.7%) separated.

Procedures

The public information officer served as the liaison between me and the institution. Interviews took place between March 7, 2006 and July 3, 2006. During this period there were 1,589 women being held in the California Institution for Women. Although participation was voluntary, it was possible that some offenders might have felt compelled to participate in this study in an attempt to appear cooperative to parole boards or prison administrators. To protect against the potential for coercion in recruiting informants, flyers were posted explaining that a researcher from the University of Missouri would be conducting research that involved interviewing black women offenders about their views and perceptions of what causes crime. The public information officer was responsible for posting the flyers and sign-up sheets advertising the research project and recruiting participants in the housing units and dayrooms. Interested women were instructed to sign-up, indicating their name, physical location, and mailing address. Since it was not possible to interview everybody that volunteered, the women were informed of this fact. Inmates were told that nonparticipation could not be held against any particular person as prospective volunteers could not be held responsible for not being selected to be interviewed by the researcher.

This research used face-to-face semi-structured interviews to gain a better understanding of African American female offenders' perceptions of what causes crime. The semi-structured interview questionnaire was designed to capture repeating ideas, themes, and theoretical constructs in regard to black female

prisoners' crime attributions. According to Hesse-Biber and Leavy (2006), the in-depth interview process provides an opportunity to gain information and understanding from individuals on a focused topic. Moreover, the in-depth interview process allows black female inmates to voice their knowledge and expertise as informants concerning their own life experiences.

The public information officer was also responsible for notifying the inmates twenty-four hours before the scheduled interview time, observing, and providing security for the interviews as well as sponsoring me during my visits. I personally conducted all of the interviews. Thirty-five inmates signed up to participate in this research project from March 6, 2006 to May 1, 2006. At the time of the study, a total of 30 inmates were available on the dates and times allocated for interviews. All informants were granted a $20 remuneration for their participation in this research study. The interviews were digitally recorded and transcribed by me. The interviews lasted from forty-five minutes to an hour and forty-five minutes. The average interview lasted approximately 1 hour and 35 minutes.

The interviews included a pre-session during which introductions were made, the purpose was explained, written consent was obtained, and the background and demographics form was completed. Consent was obtained via reading the consent form to all informants and obtaining their signatures for verification purposes. Although this research did not carry the potential for physical harm, there were other risks to potential volunteers. First, the risk that volunteers might disclose information about past criminal behavior that the authorities were unaware of was of concern. I believe that researchers have an obligation to protect their informants. According to Scully (1990), this obligation holds even when the information offenders provide is useful to authorities. In the event that a volunteer disclosed information about past criminal behavior, the confidentiality of the volunteer would be maintained. Second, there was a risk that the volunteers might disclose information about future criminal behavior. In the event that a volunteer disclosed information about intended future criminal

behavior, the confidentiality of the volunteer would also be maintained. Third, the volunteers could become emotionally distressed and, four, they could express intent to harm themselves or others during the interview. In the event that a volunteer became emotionally distressed during the interview, the interview would have been terminated immediately. The interview would not continue without the express consent of the volunteer. In the event the volunteer choose not to continue, the interview would have been terminated. If volunteers expressed intent to harm themselves or others during an interview, the appropriate officials would have been notified to assist the volunteer and ensure that no harm occurred to the volunteer or others. All volunteers were also required to read and then sign the consent form, indicating their willingness to participate in this study.

Moreover, informants were interviewed in the visiting area of the prison. Additionally, all informants assisted with the completion of a background and demographics questionnaire. The thirteen background and demographic questions were primarily closed-ended and focused on a range of demographic data including age, race, marital status, parental status, age of children, caretaker of children, education, mother's job/occupation, father's job/occupation, arrest and conviction history, sentences, and pre- and post prison mental health treatment history.

The interviews were conducted in private rooms ordinarily used for inmates to meet with legal counsel. The interviews officially commenced when the digital recording began. The semi-structured interview questions were open-ended and covered the women's childhood, adolescent and adult life experiences and their perceptions of causes of crime. Appendix 6 contains a copy of the semi-structured interview questionnaire.

Previous research analyzed causal attributions primarily in the realm of the mass media, general public, and criminal justice officials. I queried black female prisoners' views and perceptions of what causes crime and their aspirations for their future. Causal interpretations about crime have been found to differ between the perceiver of crime and the perceived criminal. This study focuses on two of

the most popular dimensions for characterizing causal attributions: self vs. other and locus of control (internal-external). To reiterate, attributions are how we explain our own and others' behaviors. We tend to explain our own behavior in terms of the situation (external explanations) but hold others responsible for the behavior (internal explanations). My analysis investigates whether women are more likely to use internal or external explanations for their own and others' crimes.

To determine if black female inmates make more internal or external attributions in regard to their crimes, I asked inmates how they came to be in jail at CIW (Question 4) and probed whether there was an event that set them on this path. I also asked what the circumstances or experiences were that stood out as important reasons that led them to that activity. As stated earlier, causal interpretations about crime may also be affected by the race of the perceiver and the race of the perceived. Thus, particular attention was given to racialized attributions about crime. My analysis focused primarily on an internal comparison of black women offenders' perceptions of other black, white, and other (Hispanic, Asian) female offenders. To get at black women inmates' perceptions of other black women, two questions were asked: "How would you explain other black women's reasons for being involved in situations that led them to prison?" and "Are your reasons for being involved in situations that lead you to prison similar or different than other black women's reasons?" To get at black women inmates' perceptions of white women's reasons, two questions were asked: "Are black women's and white women's reasons for being involved in situations that lead them to prison similar or different?" and "What kinds of reasons for being involved in the activity that led them to prison have you heard white women at CIW talk about?" To get at black women inmates' perceptions of other women's reasons, the following question was asked: "Do black women get involved in situations that lead them to prison for the same reasons other women get involved in situations that lead them to prison?"

Gendered attributions about crime were selected for analysis because, as argued in the theoretical chapter, causal interpretations about crime may be affected by the gender of the perceiver and the gender of the perceived. This analysis will focus on the ways in which the gender of the perceiver and the perceived affect black female offenders' causal attributions about crime. To get at possible gendered attributions, two questions were asked: "Are black women's and black men's reasons for being involved in situations that lead them to prison similar or different?" and "What kinds of reasons for being involved in situations that led them to prison have you heard black men talk about?"

In regard to locus of control for crimes, perceptions of locus of control among the general public can be divided into two types: internal (personal) factors and external (environmental) causes (Weiner 1974). This distinction has often been used in studies of perceptions of crime. Internal locus of control refers to the belief that one controls one's destiny. External locus of control refers to the perception that one's fate is determined by chance or forces outside of one's ability to control (Rotter 1973). To determine black women inmates' locus of control, a series of questions were asked: "If you think back over the circumstances surrounding the length of your current conviction, what are the circumstances or experiences that stand out as important reasons that led you to that activity?" I used the following questions to probe inmates' response to this question: "What was on your mind when you got involved in that situation?" and "What was important to you?" These questions were aimed at unraveling where black female inmates stood in regard to locus of control.

Numerous consequences of causal attributions have been examined in prior research that were studied in this investigation and that have implications for the futures of the women in my study. These include low self-esteem, responsibility, diminished motivation (defeatism), and expectations for the future (optimism) (Forsyth 1980; Brickman 1982; Bae and Crittenden 1983; Weiner 1986; and Nair 1994). The two consequences most relevant for this study are expectations for success (optimism) vs. failure (defeatism). Nair (1994) suggests

that attributional models adopted by female inmates are crucial to their future lives. My analysis focused on the effects of causal attributions on a specific plan for the future. To get at black women inmates' hopes and dreams for the future, two questions were asked: "During your time in CIW do you think you became more or less concerned about your future?" and "What are your hopes and dreams for your future?" To determine black women inmates' perceptions of other black women and white women inmates' hopes and dreams for the future, two questions were asked: "Are your hopes and dreams for your future similar or different than other black women's future hopes and dreams?" and "Are your hopes and dreams for your future similar or different than white women's future hopes and dreams at CIW?" At the end of each interview the digital recorder was turned off, and the women were debriefed. The debriefing included any closing remarks, comments, or questions the women wanted to make "off the record." The women were thanked for their participation and returned to their area.

Because this research involved a particularly vulnerable population, confidentiality and human subject protection was a concern. Therefore, each interview was numerically coded to protect the identity of volunteers and the code sheet was kept in a password protected file. Additionally, all informants' personal identification and information was kept completely confidential. Moreover, all interview tapes and transcribed interviews were kept in a locked file cabinet.

Analysis

The analysis for this project involved identifying: (1) causal relationships of crime; (2) gendered attributions about crime; (3) racialized attributions about crime; (4) locus of control for crimes; and (5) consequences of attributions about crime from the perspective of black female offenders. Codes were developed directly from black women inmates' responses to the semi-structured interview questionnaire. Preliminary codes were jotted down during interviews in order to develop a tentative list of codes. Next, I listened to interviews and jotted down notes on what I heard in the data. The response to each question was coded.

Finally, interview transcripts were read in order to develop additional codes as well as confirm the presence or absence of preliminary codes.

Operational Definitions of Coding Categories

In this section I will lay out the contents of relevant coding categories. I will also explain what is meant by the codes presented in the coding categories and present the specific process whereby coding categories were developed. Relevant variables were identified on the basis of codes developed from relevant literature, black women inmates' interview responses, and questions on the semi-structured interview questionnaire. The interviews were assigned a sequential number in relation to the order in which the interviews were conducted. Therefore, the first variable is "interview number." This variable ensures that each interview is accounted for.

Research states that female offenders experience problems in their early life situations (Chesney-Lind 1997). The variable "childhood" was used to determine whether or not informants had a happy childhood by American standards. Childhood has the following categories: not mentioned, happy, unhappy, happy & unhappy, and uncertain. Moreover, feminist researchers have long argued that women's pathways to crime are unique and different. The variable "delinquency reasons" was used to determine informants' perception of initial involvement in delinquent behavior. "Delinquency reasons" has the following categories: no delinquency, abuse/neglect, drugs, low self-esteem, survival, loved one(s), homies/gang, other, and uncertain. Delinquency reasons were measured by the categories "no delinquency" meaning no involvement in delinquent behavior as a youth, "abuse/neglect" meaning experience of physical, emotional, and/or sexual abuse, as well as parental neglect (of basic and/or social needs). The category "drugs" was defined as addiction to or involvement with the use, sale, transportation, and/or trafficking of any category of drug. The category "low self-esteem" was defined as a poor, negative/unfavorable view of self, feelings of worthlessness and its subsequent impact on emotions and behavior

(e.g., vices, greed, jealousy, bad decisions). The category "survival" was defined as the day-to-day struggle associated with the pursuit of money, food, shelter, etc. The category "loved one(s)" was defined as children, siblings, parents, extended family, and significant others (spouses, boyfriends, girlfriends). The category "homies/gang" referred to gang affiliates and gang banging.

Researchers note that there has been a rapid and steady increase in drug crimes and drug court convictions as well as violent crimes (Tonry 1995; Sourcebook of Criminal Justice Statistics 1995). To examine whether drugs and violence were involved I created two categories: "current case1" and "current case2." "Current case1" has the following categories: drug-related and not drug-related. "Current case2" had the following categories: violent and not violent.

According to Piquero and Rengert (1999), attempts to reduce the incidence of crime will only be effective in as far as we understand how offenders view and perceive the causes of crime. Thus, the role of extralegal factors in criminal behavior must also be explored. To examine informants' perceptions of causes of their crime(s) I created the variable "important reasons." The variable "important reasons" had the following categories: not mentioned, abuse/neglect, drugs, low self-esteem, survival, loved one(s), homies/gang, other, and uncertain. The variable "black women unique reasons" was used to measure whether informants believed that there are unique reasons black women get involved in activities for which they are put in prison. "Black women unique reasons" had the following categories: not mentioned, unique, not unique, unique and not unique, and uncertain. The variable "black women reasons" had the following categories: not mentioned, abuse/neglect, drugs, low self-esteem, survival, loved one(s), homies/gang, other, and uncertain.

Although this study does not involve a comparison group, there is the possibility of utilizing an internal comparison. To examine this I asked informants if their reasons for being involved in the activity that led them to prison were similar or different from other black women, white women, other women (Hispanic and Asian), and black men. Thus, the variables "other black women,"

"white women," "other women," and "black men" have the following categories: not mentioned, similar, different, similar and different, and uncertain. The variables "white women reasons," "other women reasons," and "black men reasons" have the following categories: not mentioned, abuse/neglect, drugs, low self-esteem, survival, loved one(s), homies/gang, other, and uncertain. The last comparison involves whether informants know of other women who have been involved in similar situations but have not been jailed. The variable "similar situations" include the following categories: yes or no.

A positive outlook in relation to one's past has benefits for one's future (Forsyth 1980; Brickman 1982; Crittenden 1983; Weiner 1986; and Nair 1994). To examine perceptions of informants' future hopes and dreams I used four (4) variables: "do over again," "concern about future," "hopes and dreams," and "do with your life." "Do over again" has the following categories: yes or no. "Concern about future" has the following categories: yes or no. The variables "hopes and dreams" and "do with your life" have the following categories: not mentioned, reunification with loved one(s), lawfulness, unlawfulness, other, and uncertain. The category "reunification with loved one(s)" was measured by content referring to mending interpersonal relationships with children, siblings, parents, extended family, and significant others (spouses, boyfriends, girlfriends). The category "lawfulness" was measured by content referring to pro-social behaviors such as employment, housing, and education as well as leisure activities. The category "unlawfulness" was measured by content referring to deviant behavior and law breaking such as drugs and alcohol use, fraternization, unemployment, and malingering.

Informants were also asked to compare their future hopes and dreams with other black women's, white women's, and other women's. The variables "other black women's hopes and dreams1," and "white women's hopes and dreams1" have the following categories: not mentioned, similar, different, similar and different, and uncertain. The variables "other black women's hopes and dreams2" and "white women's hopes and dreams2" have the following categories: not

mentioned, reunification loved one(s), lawfulness, unlawfulness, other, and uncertain. Finally, the variable "most effect" measures informants' perceptions of what will have the most effect on them in the years to come. "Most effect" has the following categories: not mentioned, incarceration, programming, discipline, social relationships, other and uncertain.

In summary, this study utilizes a qualitative research design to help determine black women offenders' perceptions of crime causality. Data were collected via face-to-face interviews conducted at the California Institution for Women. Relevant coding categories were identified based on inmate's responses to the semi-structured interview questionnaire. The sample consisted of thirty (30) African American female prisoners between the ages of 19 and 75 years-old.

CHAPTER FIVE:
RESULTS

This chapter focuses on black female inmates' perceptions of self as well as others. Specifically, I examine black female inmates' perceptions of what causes crime as well as their orientation toward the future. Additionally, I also compare the reasons given by this group of inmates for their incarceration to what they said about other male and female inmates. Moreover, I develop a typology of women offenders based on black women inmates' perceptions of their own and other women's crime causation. In answering my research questions, this study seeks to challenge the dichotomous framework developed in the literature in regard to how people think about crime causation. By using this qualitative approach to understanding women's perceptions of crime, the impact of race, class, gender, and power relations could be more thoroughly examined. Although the sample for this project is small, both frequencies and percentages were computed using SPSS.

The first research aim was to identify black female inmates' causal attributions for self vs. other. In this section I will report the findings on five questions: Do black female offenders make more internal or external attributions in regard to: (1) their own crimes?, (2) other black women's crimes?, (3) white women's crimes?, (4) other women's crimes?, and (5) black men's crimes?

As stated in Chapter four, a total of thirty (30) African American female inmates participated in this study. The average age of informants was forty (40),

with the youngest and oldest informants being 19 and 75, respectively. The data revealed that the inmates had participated in a wide variety of offenses. The majority (N=23) were violent offenders, while over half of my informants were involved in murder (N=17). Furthermore, the overwhelming majority come from extremely marginalized backgrounds.

With regard to murder offenses, ten (10) involved second-degree murder convictions, while seven (7) involved first-degree murder convictions. Attempted murder convictions comprised two (2) offenses, with assault with a deadly weapon making up three (3) and both kidnapping and conspiracy involving one (1) offense each. In contrast, four (4) property offenses involved burglary, nine (9) robberies, two (2) petty thefts, and one (1) involved extortion. In the remaining cases, four (4) involved drug-related offenses, including one (1) possession of a controlled substance as well as one (1) sale of a controlled substance and two (2) for transportation of a controlled substance. In regard to crimes related to social mores, one (1) involved prostitution and two (2) involved white-collar crimes (e.g. one (1) identity theft and one (1) for forgery).

Causal Relationships of Crime

In this section I will compare the participants' perceptions of their own crime causation with the perceived causes for other black women inmates. What is the typical causal attribution of black female inmates in regard to self? Responses showed that the offenders used two (2) types of attributions for self: external (loved one(s)) and internal/external (drugs). It is also clear that the inmates feel that loved one(s) and drugs are the predominant causes of crime. Forty percent of the inmates saw loved one(s) (N=12) as the predominant cause of their criminality. There were two (2) dimensions to the variable "loved one(s)": husbands/boyfriends and siblings. Although the category "loved one(s)" includes children, siblings, parents, extended family, and significant others (spouses, boyfriends, girlfriends), the majority (N=9) of these cases citing the cause as "loved one(s)" were in reference to husbands and/or boyfriends. Thus, there is a

distinct gender dimension to their narratives. These findings are consistent with the bulk of past research literature, which posits that women are more likely to play a secondary role to the men in their lives regarding crime and deviance (Cloward 1959; Hoffman-Bustamante 1973; Campbell 1990). In many instances, women are pressured to engage in crime by intimate partners (Arnold 1990; Bush-Baskette 1999). This was made clear by one inmate:

> I noticed that most black women are here for being there, being on the scene, just being there and it got them involved. Most black women I know are here for being with somebody. They didn't actually do it, like myself, they were just there.

Another 26 year-old inmate sums this up with the following statement: "I believe that a lot of our situations or reasons have to do with the men in our lives. I know of women catching cases for guys because if he takes the case, which is his case anyway, he has got to do more time, and so she takes the case for him." For example, this inmate describes her role in the events leading up to her and her husband's current incarceration:

> My gut told me not to go. Oh boy, I tell you, my gut told me not to go. But I was like okay, come on and I drove him to meet whoever it is we met. The gentleman did come to the car and give him a huge amount of money. I did see that much. He proceeded to talk to my husband but my husband cut him off and said, "My wife is in the car, call me later man." About a minute and a half after pulling away, I had a black and white behind me. Then I realized as I was merging to get over to the right that there was a narc behind us too. I turned and looked at him and I go, "This isn't a traffic stop because there's a narc car behind the black and white." I knew that much. He looked at me and said, "Don't worry about it, I just picked up some money. You have your license and everything, right?" I said yes. So there was no need for me to panic or anything, right? At least that's what I thought. . . . But before I knew what happened, I'm handcuffed and my kids are being taken away and they're crying, kicking, and screaming.

Other inmates believe that they were naïve and taken advantage of by the men in their lives. This inmate reported that her man had a pre-existing drug and gambling addiction, which she was intentionally not made aware of:

> Shortly after my divorce I became involved with a guy who I thought was the love of my life. After five years of being with him, I found out that he was using drugs. We had a joint account; he went through all the money in my account: checks bouncing, eviction notices, the whole nine yards. And today, I'm looking for a better term, I can only say that maybe I was naïve or I don't know. I didn't see the signs. I didn't know that he was using. I knew that he gambled, but in the very beginning he was a very good caretaker. He took good care of my son and myself. I really didn't pay attention to the things I should have paid attention to and by the time I realized that there were problems, it was too late. You know, the bank account had been depleted, and like I said, eviction notices, and the whole nine yards and that just sent me!

These remarks were echoed by several other inmates. When asked to elaborate, this inmate, whose husband is also serving time for a drug case stemming from a raid on the family home, had this to say:

> A lot of times men are the reason the women are in here. My case is pretty sad. My husband wasn't your average drug dealer. There were no corners for him or nothing like that. He dealt with large quantities. I wasn't fully aware of the type of quantities he dealt with until this. I knew of his activities, you know, don't get me wrong. But I didn't know what this boy was actually doing. He never let me in his business to the point that I knew who he was dealing with. Nothing like that, he always excluded me from that. I finally moved in with him at 16. I was excluded from all of it. It just became home to me. I seen the money, I knew he would run back and forth, but I never saw narcotics or nothing like that. It was never where he was like "go with me here so I can make a deal." None of that. "I want you at home with the kids."

Another inmate tells how her man coerced her into prostituting to support their addiction:

> I caught my first felony when I was pregnant with my second child. Of course, again, even though I was in a relationship with this guy that I had

met while I was using, I was still turning tricks and he knew about it. And this guy was black. He never said, "Go prostitute yourself or go sleep with other men to get us some money" or nothing like that. But he would wear you down, saying over and over again, "We need money, what are we gonna do?" and I knew what that meant.

Moreover, this 19 year-old inmate insisted that there were numerous friends of hers in similar situations. "As far as the young ones, like my friends, some of them are here for a boy, you know, taking up for a boy, you know, and getting involved in robberies or something, stuff like that." Indeed, this inmate explains how she became enmeshed in a clandestine relationship:

I found this little telemarketing job and that's when I met this guy in a big red truck. He was on parole himself, talking about checks. I don't know, I just didn't want to lose everything, you know, I just didn't want to lose what I had. And then I had to put a thirty-day notice down on my apartment . . . and me and my baby had to go live in a studio. It's just hard, you know, when you're use to having your own room, she got her own room, and then I don't have a job, to unemployment, to telemarketing. All these things were like in my head, "I got to give up my home, or I can stay and let them evict me but then I won't be able to get another home."

Thus, forty percent (N=12) of informants attributed their current incarceration primarily to their relationships with husbands or boyfriends. Furthermore, this inmate described her perception of the situation: "They had his back 100%, not realizing what they were getting into." Thus, supporting one's man at the expense of one's own well-being was a dominant theme in female criminality, as the following poignant comment illustrates:

I didn't place my responsibilities where they should have been. I felt that I was doing the right thing by supporting him and anything that he did and being home with my children and doing the best that I could. But my responsibilities wasn't to the right person at that particular time and that was putting me first, in order for me to have it right for my family and I didn't see it like that at the time.

Although relationships with men dominated many of my informants' accounts of their pathways to prison, they were not the only loved one(s) mentioned by inmates. A small number of inmates (N=3) perceived their siblings to be chiefly responsible for their current incarceration. One 19 year-old inmate tells a complicated tale in regard to her co-defendant who also happens to be her brother. This inmate's story sheds new light on an important dimension of female criminality, which examines the influence of siblings on crime:

> He came back after being out of town and the police were looking for him because he had a warrant . . . so I called him and said, 'The police are looking for you Brian." He was saying that he needed money so that he could get out of town or whatever. So, he was like, "I heard about this lick that I can do but I need your car because . . . He said because, "My car was low key." I don't know how my car is considered low key; it's a black Honda Civic with black tinted windows. But he said with the tinted windows, they wouldn't be able to see through them to see who was in the car. I had a job and everything. I had just graduated from college so I'm not trying to be involved in any of this. He kept harassing me though . . . My brother has a way of convincing you to do something but not convincing you. Also, my ex-boyfriend was one of his friends and he's also a gang member so they both were trying to convince me at the same time. So, when they convinced me, they convinced me that I would not be involved in anything and that they would use the car and I would just go and be okay. So, when it happened, I'm driving the car and they're telling me where to go and I'm like, "I thought I wasn't going to be involved in this?" But it seems I was also the get-away driver. So, when they went in to do the robbery, I didn't know what happened inside because I was in the car and they came out like nothing happened. We got on the freeway and the police started following us and they started jumping around in the car. I wanted to stop but they said, "No don't stop the car, keep going, keep going." We kept going but the police stopped us in an alley. I stayed in the car and all of them jumped out and ran. I felt alone and like, "They just set me up." I ended up getting arrested and all of them got arrested within 3 hours. We went to jail for attempted murder, they shot 3 people, but I was unaware of that until the detective came to speak to me. . . . Kidnapping, robbery, and then they added the evading the police charge on me.

Feminist criminologists have long recognized the role of siblings in women's criminality (Richie 1996). Another young inmate was 17 years-old

when she and her sister became embroiled in a nasty dispute with a young man in their neighborhood. In the following example, the informant describes her attempt to protect her younger sister, whom she says was threatened and harassed daily by this man:

> Okay, I was 17 when it happened and it was me and my sister and this boy that we knew had been messing with my sister and he wanted to fight her. So, me being the oldest, I'm going to take up for my sister and everything. And one of our friends was there and we told him like, you know, what was going on and he said, "Well, I'm about to go fight him," you know. They started fighting and me and my sister jumped in the fight. But my friend pulled out a gun on the other guy and he shot him. So, we got charged with the case. We didn't know he had a gun or nothing. We didn't know it was going to happen like that but it did. Me and my sister ended up getting charged with the case and my friend got off, he walked. It was attempted murder because the boy was paralyzed and he knew our names but he didn't know the other guy. But by the grace of God, we only got, I got 4 and she got 5 with half.

Although only four (4) informants were serving time for crimes involving drug-related offenses (i.e. 2 for transportation/sales; 2 for possession), twice as many inmates interviewed for this study admitted that drugs played some part in their present predicament (N=9 (30%)). There were three dimensions of inmates' involvement with drugs. First, there were those inmates (N=2 (22.2%)) that attributed their situation to drug addiction: "I'm here because I'm an addict." For instance, this inmate had this to say about her long bout with a chemical addiction:

> That was the whole thing. When I started getting high I had children. I was fifteen and it was just weed then. And then I started liking chemicals and to do a lot of that, it cost money. So, I started forging checks, using credit cards, and shoplifting to take care of my drug habit. And like I said I always thought that as long as I took care of my children and put a roof over their head, the drug thing was not any issue, but it was. But I just didn't see it as an issue then. Do you know what I'm saying? I knew that I was getting high and stuff but I was still paying my bills and my 'get high money' came from the crimes I was pulling. And I felt that the crime I was

doing was not hurting anybody. It wasn't like I was putting a gun in anybody's face but it was hurting people. I didn't see it like that.

Second, there were those inmates (N=5 (55.5%)) that attributed their situation to selling and transporting drugs for money and survival: "I was strictly hustling to make sure I paid my bills and going to work and that was it. I didn't go out, I didn't socialize . . ." Similarly, this inmate stated that she didn't even have bus fare when she started dealing.

> I knew this guy and he taught me how to hustle crack. The only way you can get that lump sum of money at one time is to sell. I didn't have money to get to my job, home, or school. So, the first time I caught a case, it was possession. I had sold everything I had and the police ran up on me but they didn't find anything but some crumbs. But I also had some weed. The next time I go down, I get 180 days, I did 22 days. And then the next year, I caught another case where I got the joint suspension that I'm doing now. This time I got caught with something on me. It was a hot block and I was in the wrong place. The following year, 2005, I violated.

Another inmate spoke about one fateful day after her attempt at a brief foray into the world of drug dealing in order to "get back on her feet."

> I met some people who were involved in drugs. Some sold large quantities of drugs and others bought small quantities of drugs. I became involved in the drug dealing part as a go-between in my attempt to try to get back on my feet. And, because of that, I ended up being put in a position where a drug deal went bad and the drug dealer ended up being murdered.

Third, there were those inmates (N=2 (22.2%)) who admitted to using drugs to numb the pain of abuse and/or neglect. For example, one drug offender describes pain behind her drug addiction:

> I always felt like the outsider, you know, and I think that has a lot to do with why I became involved in drugs. Because I just didn't feel connected to anyone. My mother worked extremely hard when we were growing up and I felt it. I really felt it. I always said to my mother, well not when I was young but when I got older, I said 'you raised us via the telephone, you know, or by note you know.' Because she was always at work and

everything that we said was either by note or she would call us and tell us. And she had babies for us to raise, you know what I'm saying, and I left home early because I felt limited. In my . . . in my growth, in my person, in my being and then I ended up having a baby at 15, so again, I was limited. You know because my mother wasn't going to take care of my baby, I didn't think she took care of her own very well. So, it's just sometimes I have just felt truly limited and because there is something in me that's not happy it makes me turn to drugs.

One 29 year-old married inmate gave a particularly insightful description of the role her addiction played in her criminal behavior:

> I believe that my criminal behavior started because of my drug addiction because I can remember before this drug addiction I used to work, you know, I was really independent. I was really, really independent. So, my criminal career progressed as my addiction progressed. I started using prostitution to support my habit. It started from prostitution and went to drug dealing. I was actually selling drugs and using drugs when I caught this case. I figured out that I could make more money selling drugs than I could prostituting. So, of course, I swung that way.

When asked about her life experiences while growing up, this inmate told of how family life involving abuse and neglect was further complicated by too much responsibility:

> I think I had a very happy childhood . . . You know what, I take that back because I was a chronic runaway. At the age of 8, my mother's boyfriend sodomized me. I was also molested by my cousin. She was 16 at the time and my mother had taken her in when my grandmother passed away. So, she molested me. I've also been touched by different men, you know, that had some kind of dealings with family . . . Then my mother married my stepfather. He never touched me or anything, but I had so much anger and I used that anger to become a chronic runaway. I spent a lot of time in California youth shelters. I never got into any criminal trouble as a child or anything. In between the times when I was in these youth shelters, I would go back home. Me and my sisters were latchkey kids. I'm the oldest of three girls. So, we were latchkey kids, so I did most of the raising of my sisters. I believe I played more of a mother role to my baby sister than my own children. I'm 8 years older than my youngest sister. So, I was forced to be the more responsible person.

The burden of domestic chores and care of younger siblings is often acutely resented by many girls. In fact, several inmates expressed considerable frustration with the domestic division of labor, beginning in their homes of origin. Without exception, these inmates reported that, in their homes, girls' responsibility for domestic chores far outstripped that of boys'. One 44 year-old inmate serving time for murder had this to say about her early childhood experiences with caretaking in her family:

> My mother had 5 of us. One of them she gave away, sent her out as in adoption. So, she kept 4 of us. When she did that to Sylvia, Sylvia was probably 5 months when she did that to her. I remember because I'm the oldest of these five girls. She was about 5 months. She was a baby and she was hooked on . . . My mom used to take reds, she used to drop red devils and whites. And so Sylvia was born addicted to these pills but at that time they didn't test for it. So, my sister was crying, and crying, and crying, but it's because she needed those pills in her system. And so I was responsible for this little girl at a young age. I was 6, almost 7, when Sylvia came along and I used to have to rock her and hold her all the time because my mom was too busy doing other things. So, that's what that was like.

Several other inmates echoed these sentiments, as indicated by the following remarks: "I had to raise myself and my 2 baby brothers; I think it was hard having so much responsibility as a child; I just wanted to be free, get out from under all that; Wanting to have my own time, I started to rebel." The following sentiment was typical:

> We have this image, we're stereotyped as being the strong matriarch and very independent, where we are very normal. We are normal but you're forced into independence. I had to wash the dishes and baby-sit and all this by the time I was 14. I was never able to be a kid and just have no responsibilities and learn and grow and experience life. Because most of us grow up in poverty, single parent homes, we end up becoming workers by the time we are seven or eight years-old. We're doing housework, we are doing chores, we are babysitting, we are combing hair, we are watching our nieces and nephews. We don't know we are becoming vengeful and bitter until one day we are in our teens and we haven't done anything. You know. I didn't have a boyfriend. I didn't go to parties. I didn't have friends when I was a kid. I didn't know the neighbor's kids,

you know. I didn't do what the media says eight and nine year-olds do, birthday parties and all that, because we didn't have money. A lot of that was common with young women who come to prison between the age of 18 and 25. We don't have those types of memories. We have memories of, "girl, I had to do the dishes or my mom beat me," "girl, if we didn't have this done or that done, I got a whipping."

As stated in Chapter four, the category "abuse and/or neglect" refers to the experience of physical, psychological, and/or sexual abuse, as well as neglect (of basic and/or social needs). Twenty percent of inmates (N=6) view abuse and/or neglect as the predominant cause of their criminality. There were three dimensions to the category of "abuse and/or neglect": early childhood, adulthood, and both early childhood and adulthood abuse. A majority of inmates (N=5) attributed their criminality to early childhood abuse, while one inmate attributed her criminality to adulthood abuse. Childhood abuse was most often perpetrated by siblings, parents, extended family, and/or fictive kin.

Although only six inmates attributed their criminality to abuse and/or neglect, twenty-four inmates (80%) interviewed for this study explicitly stated that they were victims of some kind of abuse. However these facts do require qualifying. Even though this number is high, it is consistent with the bulk of past research literature, which posits that the majority of women in prison have had lives shaped by a multiplicity of abuse (Owen 1998; Gilfus 2006; Rubin 1976). Specifically, twenty-three inmates were victims of early childhood and adulthood abuse, while one inmate reported solely adulthood abuse. Of the twenty-three inmates (76.7%) who reported early childhood abuse, 47.8% (N=11) reported sexual abuse, 21.7% (N=5) reported physical abuse, and 13% (N=3) reported psychological abuse. Four inmates (17.4%) reported being both physically and sexually abused. Of those inmates reporting sexual abuse, two (13.3%) were abused by their fathers, five (33.3%) were abused by fictive kin (godfathers and close family friends), and eight (53.3%) were abused by extended family members (i.e., uncles, aunts, and cousins). Five informants reported childhood physical abuse. Of those inmates who reported childhood physical abuse, the

majority (N=4) reported being abused by their mother. Likewise, of those inmates who reported psychological abuse (N=3), the majority (N=2) reported being psychologically abused by their mother. For instance, this inmate recounted abuse at the hands of her mother:

> The next thing I knew, everyone was in the house. I looked outside and my mother's car was pulling up, so they hid in the closet. And then my mother came home with another strange male, an older man, and she went into the walk-in closet and found them hiding in there. So, I tried to leave with them and she wouldn't let me leave. After they left, she told me in front of that man that, "I want you to take your clothes off and get into the shower naked. And I was developed at this time and she wanted to beat me in front of this man naked. And I told her, "You're not going to hit me anymore." And she said, "If you think you're a woman then fight like one." So, we fought and I left home and never been back since.

Additionally, several of those inmates (N=23) who experienced childhood abuse also indicated that this abuse was accompanied by parental neglect (N=18 (78.3%). For instance, this inmate described how her young parents neglected her: "But my background comes from my parents, you know what I'm saying, I had parents that ran the streets, you know, I had parents that put it before me, you know what I'm saying. I had parents who were gang bangers and they were always in my house, so it was all that I knew."

All cases of childhood neglect were perpetrated by parents and/or guardians. Although some inmates also held fathers and stepfathers responsible for sexual abuse, more inmates mentioned godfathers, uncles and/or cousins also as perpetrators of sexual abuse. This inmate recalls the violent rape she endured at the hands of her godfather. As she explained, "the abuse came from being molested at a young age."

> The night I got raped, my mother . . . we were looking for my mother but she was nowhere to be found. When they did finally find her, she came home and they took me to the hospital and stuff like that. Her best friend stayed upstairs from us, so I was upstairs at their house. Her best friend is my godmother. She took me to the hospital and she was with me and

everything. But come to find out, the dude that had just beat her up, she was at his house. I was like, "Man, I didn't understand that." but who was I, you just don't ask questions and stuff like that. But come to find out this man was married, he had a house in Compton, about 5 kids, and he's beating on my mother like it's the thing to do and she's taking it. None of us are his kids, me or my 2 brothers, we not his kids and she was going through this and stuff. So, she was never there for me and everything. I think I fell out with her when we were going to court behind what happened, the rape. I guess she got tired of going back and forth to court but I needed to go to court because he did this to me, you know and everything. And she was like, "You probably was flirting with him." And from that point on, I think I just locked that in my head and I didn't look at her as no mother anymore.

Other inmates confirm the prevalence of abuse in the early life experiences of incarcerated black women. According to Owen (1998: 44), "the impact of abuse has long-term consequences on the lives of women in prison." When asked about her earlier life experiences while growing up, one 27 year-old inmate had this tragic story to tell:

To me, it was sad. I had a sad childhood. My mother was really strict. I mean she was strict. My mother was the enforcer in the house and she was physically and emotionally abusive. She would say one thing when she was sober, but when she got drunk, she would say things like, "You ain't gonna amount to nothing." . . . I grew up all over Los Angeles because my mother didn't stay anywhere too long. She was constantly moving from house to house. Why? I never knew why she did it. But there was no stability, so I didn't have permanent friends all the time. With my sisters, I was a loner because I was molested. I didn't talk very much, not even to my mother. And my father, well he had 19 kids. I was molested by my brother and sister, his children. So, I spent a lot of time trying to stay away from people because of what happened to me.

As stated above, only one inmate had not been abused during her childhood yet became an adult victim of abuse. Thus, twenty-four inmates (80%) interviewed for this study explicitly stated that they had experienced adulthood abuse. All cases of adulthood abuse were perpetrated by husbands or boyfriends.

Thus, these findings support Richie (1996), in which it was found that abuse is more likely to be at the hands of boyfriends, lovers, or husbands.

Additionally, 10% (N=3) of inmates interviewed mentioned low self-esteem as the predominant cause of their own criminality. For instance, this inmate had this to say:

> I use to go on vacations with my cousins and they would say stuff like, "Why do you always have to come with us, why don't you go with your own mother?" You know, "Why do you always have to come on our vacation with us?" I still think about those words a lot. I grew up in a lot of pain because I never felt that I was good enough, ever, to be anything."

Earlier in the same interview, this 42 year-old inmate serving 25 years to life for first-degree murder and robbery told how her self-worth was eroded:

> My mother was a beautician and worked 9 to 9 six days a week. My father was a street hustler. He had women, he was a pimp, a gambler, he had liquor . . . taverns. You know, he lived that, you know, street life. My mother was more society; they were two opposite people, completely opposite. They fought a lot, there was a lot of physical abuse . . . I don't remember not one time getting a hug from either one of them. . . . Because since the age of 8 or 9, I was having sex and I was having sex out of loneliness. It started out as loneliness and out of loneliness it became rape because being around these young boys which I had had sex with at such an young age, they would come around, they started coming around in gangs. And it was like, "You better do it or we're gonna tell." And I was being sexually molested, raped, you know . . . one full summer, one whole summer, at least once a week, I was going through this. So, after this I just found myself always looking for love in the wrong places. That was my feelings, that was the only way I could get somebody to show me any love was to have sex.

Inmates attributed low self-esteem to what Bush-Baskette (1999) terms the devaluation of women in general. This inmate tells of her molestation at the hands of her father from the age of 7 to 14, which subsequently deprived her of her self-respect and self-worth:

I tried to tell my mother many times but she didn't believe me. Then I grew up and I became real rebellious and ditching school and . . . I had some problems understanding . . . moving forward because it was . . . I had a good life until that started happening to me. And like I said, my mom didn't believe me and other than that I had a good life. Because I was, you know, raised by good parents, to me, even though my Dad was molesting me for a long time. I said for a long time that it was my uncle because I didn't want to hurt my mom . . . I would act like that to other people. And when I got into junior high, I started ditching all the way through and I had low self-esteem. And still today my mom doesn't know why but as of last week she now knows why.

She continues:

I went to junior high school and then I barely graduated high school. I got out and moved on my own and I was doing good because I moved out of the house and away from the molestation. The molestation stopped at 14. And I had a lot of animosity and anger at my father but I had to hide it because I didn't want to hurt my mother. . . . But my parents did everything in the world for me. I was raised what you call "rich." I lived in South Pasadena, San Marino, Tarzana, Woodland Hills, Encino, I was raised very wealthy. I was raised . . . I got most everything that I wanted and that hindered me as an adult. It made me depend on my parents when I needed money to pay my bills . . . and then men became an issue in my life. I felt I needed a man to validate me, to make me feel more complete.

As stated above, the majority of the inmates (N=26 (86.7%) interviewed were overwhelmingly from extremely marginalized or lower-class backgrounds. No inmates interviewed indicated survival and homies and/or gang as causes. Thus, Black women inmates identify primarily two (2) types of attributions regarding perceptions of their own criminality: external (loved one(s)) and internal/external (drugs).

Typology of Crime Attributions

As stated above, inmates were asked to specify what they believe causes crime. Varying types of crime attributions may be conceptualized as typologies of what causes crime. In this section I will present a preliminary typology of black

women inmates' attributions for what causes crime. The typology was developed from informants' attributions for their own crimes. Black women inmates' crime attributions were categorized into a typology with four types of causal explanations. This study synthesizes black women inmates' crime attributions and suggests a four-category typology for defining and describing how black women inmates get involved in situations that lead to their incarceration. These four categories are not mutually exclusive and there is some blurring of the boundaries between them. Moreover, some inmates incorporate elements of two or even three aspects of the categories. The quotations in the following sections are given as examples of inmates who predominantly identify with one category, although they may also display features of the other categories. The four categories are: riders (influenced by loved one(s), clubbers (drugs), scrappers (abuse and/or neglect), and busters (low self-esteem). Comparing various types of attributions for criminal behavior will allow me to identify different underlying processes resulting in crime. Such efforts might also improve the effectiveness of rehabilitation programs by identifying which types of attributions women use and designing programs to address one of the major behavioral consequences of causal attributions (i.e. recidivism).

Riders - The Rider Attribution originates in the phrase "ride-or-die" within black discourse in popular culture rhetoric. "Riders" are those women expressing the willingness and commitment to do anything for loved one(s), no matter the cost (Blacksmith 2005). Furthermore, also implicit in the true meaning of "ride-or-die" is the idea that true riders do not snitch (i.e., tell on someone else). Stated simply, riders generally just go along with someone else's program. The category "riders" include both groups of loved one(s) discussed earlier in this study. Twelve (40%) of inmates were riders. For example: "My brother has a way of convincing you without convincing you."

Clubbers – The Clubber Attribution originates in the slang expression "clubber" to describe someone who likes to party a lot. Substance abuse and addiction frequently accompany one's initiation into this underground subculture.

Therefore, "clubbers" are those women who are deeply enmeshed in the urban underground drug scene. The category "clubber" includes drug users, dealers, and women who use as well as sell drugs. Nine (30%) of the inmates interviewed for this study were "clubbers." For example: "I'm here because I'm an addict."

Scrappers - The Scrapper Attribution also originates in a slang expression used to describe someone who frequently gets into fights. The category "scrapper" represents those women who cite "fighting back" in abusive or neglectful childhood and/or adulthood situations. The women within this category face a more uncertain future. The majority of women were facing indeterminate sentences and therefore uncertain as to when they will be granted release by Governor Swarzennegger. In fact, many women reported more than one unsuccessful parole board hearing. Furthermore, inmates stated abuse robs survivors of their power and many survivors can become mired in a cycle of self inflicted abuse. Six (20%) of the inmates were "scrappers." For example: "I was the one being beaten."

Busters – Busters invoke *The Low Self-Esteem Attribution.* Likewise, the term "buster" originates within popular culture rhetoric and began to be used to describe someone who acts like a pushover, is emotionally weak, and has low self-esteem. Three (10%) of the inmates interviewed for this study were "busters." For example: "I grew up in a lot of pain because I never felt that I was good enough, ever, to be anything." The four categories noted above provide a framework for explaining my respondents' perceptions. In the following sections, I draw on the proposed typology to better understand the women's perspectives of the behavior of other inmates.

Racialized Attributions About Crime. As stated in chapter four, particular attention was given to racialized attributions about crime. In the following section I will present the reasons informants give for the criminal behavior of other women. A somewhat different pattern emerged for respondents' perceptions of other women inmates' criminality. Black female prisoners predominately mentioned one (1) type of attribution in regard to other black women prisoners'

criminal behavior: internal/external. The women view drugs as the predominate cause of other black women inmates' criminality. One-third of inmates cited drugs as the predominate factor. Specifically, the most commonly mentioned attribution here was drugs (N=10 (33.3%) as typified by the following remarks: "A lot of black inmates are in on drug related charges; Doing drugs or selling drugs; My "celly" has been in here since she was 17 years-old and she's still hustling in prison. She has a wife with a 2 year- old."

Not surprisingly, those women citing drugs as the predominant cause of their criminality were also more likely to cite drugs in regard to other black women inmates' crimes. "Clubbers" (N=7 (70%) were more likely to cite drugs as the predominate cause of other black women inmates' crimes. The following statements are typical of "clubbers": "I notice here a lot of black women are repeat offenders that return every ninety days or so. They're either doing drugs or selling drugs and still want to be who they were years ago." When asked about other black women's criminality, this "clubber" replied:

> It's what black women get involved with, what drugs they get involved with. Like me, it was just marijuana and if you would have asked me back then, no, I don't do drugs, I just smoke weed. You know, I don't do drugs because drugs are bad for you. But, no, people get involved, they smoke sherm, crystal, heroin, meth, crack and those are some high powered drugs. Like, even like, acid, it gets your mind, like, from people who I know who have done these drugs or whatever, it makes your mind . . . Like, it changes your whole perception of life, your perception of everything.

This "clubber" had this reply:

> Like you know, a lot of black women have been in drug abuse and recurring instances where they were on drugs and was out there chasing whatever drug of choice and you know wasn't caring about the consequences and was out there doing any and everything they needed to do to get what they wanted. And they got caught up and now they're feeling the consequences of it.

However, illicit drugs were not the only drugs cited, as one "clubber" cited alcohol in the following story:

> A lot of black women in here are alcoholics and alcohol brings violence, just period, point blank. You get drunk, you drink or whatever and you're feeling it or whatever. But it always turns to violence and if anybody comes at you foul or sideways, whatever, you know what I'm saying, it can even be something small, they flip out, flash, whatever and just go there, you know what I'm saying, ready to fight, ready to kill somebody, ready to stab somebody, ready to hurt somebody, you know what I'm saying. So you can get that anger out, so you can get that anger out.

Regarding the three remaining women citing drugs, two "riders" (N=2 (20%) and one "buster" (N=1 (10%) cited drugs as the predominant cause of other black women's criminality. This 29 year-old rider (N=1 (10%) serving time for assault shared her perception of the problem:

> Most of the black women I met here, most of them are here for drugs. I can't relate to that, even though I'm in SAP (Substance Abuse Program). That's why I see a lot of them that are in here for drugs. I'm not a drug addict, you know, I've never used drugs or nothing. So, it's, like, shocking to me to see that there are so many people coming back and forth to prison, you know. It's like they have kids, they have a life out there but yet they choose to live it in prison. I really don't understand it.

These sentiments were also echoed by the following "buster" (N=1 (10%), who laments:

> Some of the women I talk to, the black women, all I hear them talk about is, "When I get up out of here, I'm going to score me some pieces." When I hit the yard, that's all I hear is drug talk and alcohol, that's all you hear is anything to do with drugs.

According to the fundamental attribution error, individuals most often explain their own behavior in terms of the situation but hold others personally responsible for their behaviors (Ross and Nisbett 1991). However, some contemporary researchers have expressed a more general discomfort with the

fundamental attribution error. Responsibility for outcomes was seen as more situational than personal for both self and others: the fundamental attribution error was not evident.

Although most of the inmates did not minimize personal responsibility for their behavior and the behavior of others, some inmates made connections between other black women inmates' situations and the issue of low self-esteem. Seven inmates (23.3%) in this study cited low self-esteem as the predominant cause of other black women inmates' criminality. Four of the inmates said that other women's problem was low self-esteem. These four were "riders." Only two "busters" (N=2 (28.6%) cited low self-esteem. A 39 year-old "rider" convicted of second-degree burglary and serving 6 years had this to say about other black women:

> I think black women feel so burdened down with having to be, I'm not saying that white women aren't single parents and that Mexican women aren't single parents, but I think that that's really a blow to African American women to have to raise children on their own. Because either they're very good at it or they ain't good at it at all. You know, it's no medium when it comes to that. Either they're very good at it, a very good single parent mom, out strong and everything, teaching their kids how to hold their heads up and be about it or whatever or they're just missing in action, you know. I think that it's that, not only just being a mother but being an African American woman period, who has been redefined, that's what I call it, by society not only how we should look but how we should act, you know. And I think for those of us who can't make our skin lighter or have our butt bigger or have that hair long or whatever, you know, and look like Halle Berry, it's like a burden to some of us who aren't strong already in our minds and, consequently, in our skin.

The following "rider" provided this assessment of other black women:

> But I think a lot of times that black women do crime because they don't know any better and they don't have the self-esteem, the self-confidence of saying, "No, I don't have to live my life this way." That's comfortable to them, a comfort zone. Because that's what we do. But to step out of that comfort zone you have to have somebody to say, "Girl you can do this. Honey don't forget that you don't have to live that way." Most of the time

> you have to go back to the environment that you left when you went to jail. They're building private prisons, you can buy stock in a prison now. But, on the other hand, what are you doing to reform anybody? You give them $200 when they leave, you tell them, "Bye-bye, you're on parole, stay clean, I'll see you next month, I need you to pee in a cup." But you're not telling them how to stay clean, how to get a job, you know, so that they can do it, that they are somebody, that God loves them, that they are here, that they have a purpose. You're not doing that, and they sure don't do it with black women.

This "rider" also highlights the role of low self-esteem regarding other black women's criminality.

> I hear a lot of them [black women] being insecure, telling me something they're not and getting themselves involved in a situation they can't handle. Then it becomes detrimental to their life for them to get out of the situation. So you got assault charges, you have murder charges, or you were involved.

Furthermore, the following is a response from a 46 year-old "buster" serving 7 years for second-degree robbery:

> I think some of us have unique reasons but a lot of black women have the same reason. They are looking for love and are unable to find it and they look for it in all the wrong places. They look at someone bad and expect to find good. They are empathetic to a lot of the men that they get involved with. Because we think we can fix the situation because if we show them that we really love them that will fix everything, not knowing that their issues are deeper.

Likewise, the 27 year-old remaining "buster" serving 5 years for identity theft had this to say about self-esteem:

> We all get molested, whether by some uncles or somebody in the black family that is doing things to our children that is causing our kids to go inward and not be able to express themselves and be the best that they can be because they develop low self-esteem. I think they develop a hate. Either you are gonna go inward and hate and not be anything or go inward and hate and have determination to be.

Only one "clubber" (14.3%) referenced low self-esteem. The 36 year-old who is serving 4 years for drug transportation and sales had this to say:

> They feel like they are at the bottom. Even though there's Oprah and Maya Angelou, they don't think it's something that they can attain. Black women feel so burdened down. I think it's a blow to African American women to have to do it all alone.

Additionally, six inmates (20%) cited abuse and/or neglect as the cause of other black women inmates' criminality. A majority of these women were "scrappers" (N=4 (66.7%). The following are typical scrapper responses to this question:

> Relationships with men! It seems that a lot of women have had bad relationships that helped them end up in prison. I know that there are a lot of black women here who have murdered their significant others because of abuse. And I think that there are more white women here that have murdered their husbands than black women. And they openly speak about the abuse. You know, some of these women have been here 20 years or more and they still talk about it as if it was happening yesterday. The abuse they endured probably led them to taking the abuser's life.

Another "scrapper" provides what she believes to be the reasons why numerous black women get incarcerated:

> It's got to be something that has to do with saving their life or their family getting out alive themselves—meaning they are being put in a situation where they're at risk, they're in danger, so. At least that's what I'm learning by hearing black women's stories here.

Finally, this "scrapper" provides a graphic picture of the role of abuse and/or neglect as the cause of other black women's criminality:

> Well, in my 17 years here, the black women I know . . . We'll talk about lifers versus short-timers. The lifers that are here have killed their abuser boyfriends and it has been the only crime they have ever committed.

Furthermore, only one "rider" (16.7 %) and one "clubber" (16.7%) cited abuse and/or neglect as the cause of other black women inmates' criminality. This 29 year-old "rider," serving 3 years and some months for burglary and extortion, had this to say in regard to other black women inmates: "I notice that most women in prison, black women, have been molested in their past." Finally, this 22 year-old "clubber," serving 5 years for selling and transportation, explained: "Well, the thing I've learned in here is that 1 out of every 3 women have been molested, sexual abuse, that's one thing I know we have in common, a lot of us."

Five inmates (16.7%) cited survival as the cause of other black women inmates' criminality. Three of the women citing survival were "riders," while two "scrappers" cited survival. One self-identified "scrapper" serving life sums up the category survival with the following statement:

> I've learned that it's survival crimes, they commit survival crimes. For example, a girl or a woman who starts prostituting to support herself but it's not hard to prostitute herself because she is used to being touched when she didn't want to be touched.

Carolyn, a 75 year-old "scrapper" serving 25 years to life for conspiracy to commit murder, offers this analysis of black women offenders:

> The black woman has no education, has worked in low paying jobs, and that goes along with lack of education and poverty. So, she understands that fact.

One "rider" offered this analysis of black women offenders:

> I think a lot of times black women commit crimes because they have to. A black woman will be a prostitute because that's the only way she knows how to make her money.

Another "rider" had the following to say:

> We have no business being a housewife and mother at 17. Black girls are forced to be too independent too young. We never learn the difference

between assertive versus aggressive behavior and so we are in survival mode by our 18th birthday.

The remaining "rider" offered the following explanation:

> Now sisters are just in crime because, "I'm hungry," "My kids are hungry." They're stuck. Maybe I was saved by prison. For sisters to be homeless, foodless, with all these resources. Black women are very prideful.

A substantial minority of "riders" cited loved one(s) (N=2 (6.7%) as the predominant cause of other black women inmates' criminality, while no inmates cited homies and/or gang. As directly put by one "rider," "There are a lot of girls that are in here for doing it for a dude . . . or to take care of their families."

My interpretation of these data is that in some cases respondents see other black women's criminality as influenced by similar forces. It is quite clear that "clubbers" tend to perceive drugs as the predominate cause of other black women's crimes. It is also clear that "scrappers" were more likely to view "abuse and/or neglect" as the predominant cause of other black women's crimes.

White Female Offenders. Black female offenders identified two (2) types of attributions in regard to white female offenders' behavior: internal and internal/external. Black female inmates view low self-esteem and drugs as the predominate causes of white female offenders' criminality. Low self-esteem was cited by eleven (36.7%) inmates in regard to perceptions of white women inmates' crime causality. A majority of "riders" (N=8 (72.7%) cited low self-esteem in regard to this group of offenders. For instance, this 23 year-old "rider," serving 7 years for assault with a deadly weapon, had this to say about white women's reasons:

> Their reasons are that they were bored and they didn't have anything to do. They were either coming from a family that had more money, you know, out there on drugs, and just living their life carefree or whatever. Whereas, black women, most of them are in poverty, you know, don't

have that much money, out there just struggling and they just doing it to survive. A lot of white people don't really have to do it to survive.

One "rider" explained:

> Some white women are dealing with abandonment issues. So they have no self-esteem, no self-worth. They are humans too and we are women period.

Another "rider" provided the following infamous case as an extreme example of the complex issue self-esteem:

> White women commit crimes of passion . . . Jealousy, I mean, um, probably the passion. Just like Amy Fisher, she believed Joey Buttafuoco. It's just like a Lifetime movie kind of a scenario where black women don't do that kind of thing. Pay me and I'm gone. You're not going to just go shoot somebody, you will shoot somebody who has raped you and continuously beat you.

Similarly, this "rider" simply attributed white female offenders' situations to an immature desire to have fun:

> I think they [white women] are just doing it, just to be doing it just to have some fun. The Caucasians are. That's how I feel about that. A lot of them are . . . because they're not from the hood.

Thus, there was a considerable amount of consensus among the riders' perceptions regarding white women offenders:

> Well, a lot of them [white women] what was important to them, like the money they get or a bigger house or a Benz or a bigger diamond ring. A lot of material reasons.

Finally, this "rider" described how television influences the self-esteem of white women:

> Because a lot of them [white women] have low self-esteem because they want to go get surgery to please their husbands, you know, to be a star. A lot of them want to be like the people they see on TV.

Not surprisingly, all of the "busters" (N=3 (27.3%) believed that self-esteem was the predominant cause behind white female offenders' criminality. The following is an example of a typical comment offered by the busters in the group:

> I think white women and black women inmates' reasons are different. I got a lot of white friends in here who come in and out and everything and there situation is different. I'm not understanding. On the Caucasian side, their life is dull and I guess they get into some situations. A lot of them come from some backgrounds and families that you are like, "why are you out there doing the things you're doing and you come from better" . . . You know what I'm saying? I look at it different for black women because a lot of them did not have what they had. We didn't have one-fourth of what they had. So, they had to struggle to get it the best way they know how, you know, and some of them just get caught up.

Additionally, the category "drugs" was cited by all nine clubbers (30%) as the predominant cause of white female criminality. For example, this "clubber" elaborates on the complexity of the drug issue with the following statement:

> Drugs don't discriminate because everyone wants to feel good. They don't only become addictions to black women, purple women, white women, or yellow women. It's universal. It's a universal problem, I believe, because everyone wants to feel good. And when you're hurting, to numb yourself, you know, it's ideal, you know, so . . . Sometimes there's nothing to do but give up and get high.

She continues:

> Drugs because they get strung out on methamphetamine. I think black women tend to have more violent cases than stuff like that, than white women because most of the time they are strung out on heroin or methamphetamine or things like that. So, I mean, it goes both ways for the drugs but I think it's more white women that do those drugs than black women do.

This "clubber" supported the idea that some white women have literally grown up in the streets:

Like I said, it's basically drugs because if you ain't had your parents there with you, you know what I'm saying, to guide you in the right way and you just are raising yourself on your own. Say your parents died and you ain't got nobody. Like, if you were up in age, eight or nine years old, and all you know is the streets. You know, that's your family, you know and what they're out there doing, you're going to want to do it too because you grow up around it.

Likewise, another "clubber" shared this recent encounter with a Caucasian female inmate: "Matter of fact, I just talked to this white girl and she's crazy because she's about to get paroled and all she can think about is her next hits. Drugs." Similarly, another "clubber" echoes these feelings: "White women have an addict mentality, using people for drugs and stuff." While prescription drugs were also cited as a major factor in white female criminality, the role of methamphetamine addiction also raised serious concerns among clubbers:

White women are more prescription drugs, they do a lot of prescription drugs. I met a lot of white girls that were, like, into meth, meth, but a lot of prescription drugs too. They're doing crime for the same reasons we are; to take care of our habits and to take care of our children. You know, the very same reasons. They're just white and we are black, you know. I thought crack was horrible but methamphetamine is uhh. They're scary . . . but I'm not saying my drug was any different from her drug but, uhh, meth ain't nice. I'm looking at these girls and their faces are all pitted out . . . addictions were reasons having to do with

Among all the "clubbers" whom I interviewed, most of the reasons dealt with the pull of the drug itself. The following is a typical "clubber" response: "Most of the white women that I've seen in here, they're like in here for like drugs, using, you know, stuff like that." Indeed, this clubber's comment illustrates a common perception:

A lot of white women here that I know are addicted. A lot of them come back because of drugs, either it's crystal or heroin and once someone falls into that mentality and that drug abuse . . . That's the majority of people that return.

Finally, this "clubber" shows how easy it was for another white female inmate to get "caught up" in a drug case:

> This one girl, she was a white girl, she was just telling me that she was going to get the dope but what happened was they ended up pulling her over and that's how she got caught up. Because she had dope on her and she was going somewhere to get dope, that's how she got caught up.

Sadly, once involved with drugs, drug related offenses provide the pathway to imprisonment for too many American women, as the following "clubber" illustrates:

> It seems like just, um, their reasons is more like just, um,… their reasons is like dope too, you know, because that's just like the majority of everyone doing time is because of all different kinds of dope. But I can't relate to them when they talk to me or whatever about it. It's like, I just can't relate to them.

Abuse and/or neglect was also cited by seven inmates (23.3%). Six (85.7%) of these were "scrappers," while only one "rider" indicated abuse and/or neglect regarding white female offenders. For example, the following is a typical "scrapper" comment:

> Most white women are here for spousal abuse. I think it's more spousal abuse. It's some here for drugs but I think it's more spouse abuse. I got this friend and she's here for killing her boyfriend. She says it was because of spousal abuse.

Moreover, when this "scrapper" was asked about causes of crime in regard to white women offenders, she had this to say:

> Many of them [white women] have been put in a predicament where they were being abused and being beaten and their children were in jeopardy and they took action into their own hands and they ended up in here.

Another "scrapper" offered this explanation:

> There are white girls in here that grew up in messed up homes with daddy
> and uncles molesting them, you know, all kinds of weird stuff going on
> and they end up chasing drugs and end up getting into the life. They might
> have come from a different background but what remains the same is that
> they are here.

Likewise, this "scrapper" also noted the prevalence of abuse among white women offenders:

> Many of them were getting abused and they committed murder. Because
> they were getting abused and they felt that the only way to get out was to
> alleviate the problem in that manner. You know what I'm saying. I feel for
> them. I feel, like, in certain situations a white lady versus a black lady,
> we're more, I guess, stronger, we grew up tougher. You know. We got a
> little bit of a thicker skin. So certain things we were able to live through
> and get over. I found a lot of times I hear a lot of Caucasian ladies saying
> they broke down, they had a mental lapse.

A substantial minority of "riders" selected loved one(s) (N=2 (6.7%). One "rider" provided this explanation:

> Here is the white woman and she probably came from a wealthy family
> and has a good education but she fell into the same trap with her
> boyfriend, used her education for embezzlement or whatever... My new
> roommate, her restitution is 3 million dollars because she got caught up
> embezzling from the corporation for which she worked. She's an
> accountant.

Survival was cited by one "rider" (3.3%) in regard to perceptions of two particular white women inmates' crime causality. She explained: "It was for the money, both of them was for the money. Like getting into crime for the money or like they want to support their kids and stuff like that." No inmates selected the category homies and/or gang in regard to perceptions of white women inmates' crime causality.

In summary, my data show that "riders" (N=8 (72.7%) are more likely to cite low self-esteem as the predominant cause of white women's criminality. Likewise, all three "busters" also cited low self-esteem in regard to this group of offenders. Notably, those women citing drugs (clubbers) as the predominant cause of their criminality also cite drugs in regard to white female inmates' crimes. Finally, when asked to elaborate on white women's reasons, "scrappers" overwhelmingly identify abuse and/or neglect.

Other Female Offenders. Black female offenders predominantly identified one (1) type of attribution in regard to other female offenders' behavior: internal/external. Black female inmates cited drugs as the predominant cause of other (Hispanic/Asian) women's criminality. Thirty percent (N=9) of inmates cited drugs. Specifically, eight (88.9%) "clubbers" and one (11.1%) "buster" indicated drugs. For example, this "buster" remarked:

> Well, my understanding is, there are a lot of young girls around my age here for selling drugs.

Likewise, the following is a typical clubber's remark:

> I know this Filipino woman and her reason for coming to jail was trying to get some money for drugs. To make this large transaction and drug trafficking. And the women seem to me are taking on selling drugs and transporting drugs, and stuff like that. They've moved up but basically behind it all, it goes back to drugs.

Another clubber described how the popular stimulant drug crystal methamphetamine shaped the life chances of one Asian inmate:

> Oh, I have an Asian woman in here right now. She's Cambodian and the reason she is in here is because of drugs. Crystal meth is taking over and a lot of people are hooked on that. A lot of people are getting hooked on that and losing everything. And that's the reason she's in here is for drugs.

Moreover, this "clubber" addresses the all too often secondary role and participation of Hispanic women in drug selling:

> A lot of their crimes [Hispanic women], they were together helping their husband or boyfriend sell drugs and a murder occurred and they went with the boyfriend to do it.

Six inmates (20%) cited homies and/or gang. Of these six, four (66.7%) were "riders" as well as one (16.7%) "clubber" and (16.7%) "scrapper." The following is a typical rider remark regarding Latin American women, "they say things like, 'the homies were there,' 'we were getting high,' 'we did this drive-by,' gang banging. The big traditional like OG, they are in there for gang-banging. Thinking they're balling." When asked to elaborate on other women's reasons, another "rider" shared these sentiments:

> Latina women situations are different. They are more likely to gang bang, you know, stuff like that. And followers because they have this real bad over here with that homie situation. I don't believe in homies. Homie can be somebody that has slept at my house, ate at my table, and I have slept at your house and ate at your table. I know your parents, you know my parents. Whatever, we have ran the street together, went to school together. That's what a homie is. But, in here, it's misconstrued in here.

Similarly, this "rider" described the important role of gangs in the lives of Latina women behind bars: "I believed that it has a lot to do with gang activities. They are really loyal to the hood." In like manner, this "rider" described the increasing visibility of Mexican girl gangs:

> They create more crime; Mexicans create more crime than blacks because they got this gang banging out there, like bang, gang-banging everywhere. Every time you go to jail, you don't see nothing but gang bangers.

In a similar manner, the remaining "rider" sums the gang issue up with the following insightful quip:

It's becoming now where most of them is like youngsters. You got this neighborhood saying, "Hey, I'm on 21st street so this is our hood. So, all in that area is like hooking up into one little set. So you got the 18th Street gang over here, saying, "Hey, all of us is over here, so we're against these over there. So if you're from 18th street, it doesn't make any difference if you are Latina, African American, you all of a sudden got this bond, you got security and that's what's happening to our youngsters out there today. They're ganging up.

Additionally, five inmates (16.7%) mentioned loved one(s) in regard to other women's criminality. All five were "riders." This "rider" offered the following: "Being manipulated by men, you know. Hooking, you know, out trading their selves for drugs to support the habits of their man, pimp, whatever, neglecting their kids." Another "rider" continues: "Women easily get caught up with a man. The majority of women in prison are here behind a man."

Likewise, under one-quarter of inmates (N=5 (16.7) cited low self-esteem. Three "riders" and two "busters" referenced low self-esteem. The remaining "scrappers" reported survival (N=3 (10%) and abuse and/or neglect (N=2 (6.7%). In summary, "riders" (N=5) cited loved one(s), homies and/or gangs (N=4), and low self-esteem (N=3). Most importantly, the overwhelming majority of "clubbers" (N=8) identified drugs as the predominant cause of other women's crimes. However no clear pattern emerged for "busters" or "scrappers" here.

Gendered Attributions About Crime. Finally, I will compare black women inmates' perceived causes of black men's criminality. Black female inmates mentioned two (2) types of attributions for black men's behaviors: internal and external. Black female inmates view low self-esteem and survival as the predominant causes of black men's crimes. Ten (33.3%) inmates mentioned low self-esteem in regard to perceptions of black men's criminality. The following remarks are typical: "Yeah, black men, some of them are addicts but I think mainly they feel like they have something to prove. Men have a lot of greed. He enjoyed having that extra $1,000 every month. He lost hope. He would tell me how, 'It's different for men.' In the beginning, it was cars, clothes, girls, you

know, that image. For the love of money." Four "riders" (40%), four "clubbers" (40%), and two (20%) "busters" cited low self-esteem. Ironically, black women inmates perceived the challenges facing black men inside as well as outside of prison as worse than their own.

> Again, because black men go out there to rob, steal, just to get money and try to come up more. Either they turn it over, try to buy a car, or whatever they trying to buy.

The following is a typical "rider" response in regard to black men's struggles to survive in contemporary society: "It's harder for black men in prison and out on the streets." Thus, nine inmates mentioned survival as the predominant cause of crime: "As he grew up, he just wanted to make sure that his kids had what they needed. The financial stressors on black men are overwhelming." Four (44.4%) "riders," four (44.4%) "scrappers," and one (11.1%) "buster" mentioned survival. One "rider" had this to say about black men:

> I think black men want to be alpha dog. Some black men, they have to prove that they are a man because they are so low on the totem...A lot of the men that I know that sell drugs or got into things to make money, they had no other options, you know, and as I said, a lot of them want to be the alpha and support their families. And it's a limit to what they can do legally, a lot of times, where I come from.

The following represents a typical "rider" response:

> Maybe because they are supposed to be the providers but they don't have a good job and they don't have the education, so what's left?

Another "rider" expressed the following sentiments:

> I just know that it's a lot harder for them, it's a lot harder for them in prison. I just feel like it's got to be rough. This is one of the things that I know about black men is that I know that it's not so much the drug use for them but it's the money because they would rather sell drugs and get that money than to go to work at Jack in the Box or construction because it's

so much more money in that, in selling drugs, than it would be for them to go and have to start all over and work at Jack in the Box or whatever.

In addition, for some women, black men must survive amidst numerous socio-structural obstacles, as the following "scrapper" illustrates:

> You fill out resumes, you go . . . you fill out applications, you get doors slammed in your face. Say this goes on for a month and you still haven't got a job. Your attitude is like, "fuck this," you know . . . No one's going to give you a job. I went out here everyday, I put in the work, I went to EDD, I went to every organization that every person in the free world has told me about. I went to McDonald's and they turned me down, I need to do something. Now I got a gun in my hand, now I'm threatening a whole family to take a wallet, now I've scared these kids to death, but what else am I going to do to feed my family. I'm a grown man in my 40s on GR, $212 a month, and $125 in food stamps and I have a family, a woman. How do I feel as a man? How do I feel as a person? You know. My money is once a month, what else am I going to do?

What is more, this "scrapper" offers a structural analysis that belies the American ideology of individualism. She believes that institutional racism may affect black men's life-chances the most:

> There are parts of me that know that the government structures the establishment to purposely do shit. You know, to perpetuate the imbalance, to perpetuate bullshit that goes on in the black community and black family by promoting women over men or men have to resort to crime, or not really reaching out or trying to set up an established program. Something that empowers black men. They don't want to empower black men. I think the black man is public enemy number one. Only the black man is a threat, I believe that the establishment looks at a black man as a threat.

Taken together, these results support the conclusion that respondents are not fooled by the American cultural narrative. Beyond such individualistic concerns, several of the women indicated that the plight of American black men was due to the accumulation of risk factors. For instance, this "buster" remarked:

> Maybe the men, maybe because they are supposed to be the providers, you know, the family, and they end up in prison because they don't have a good job, they don't have an education, so they go out and do things that are illegal to try and take care of their family.

Six respondents interviewed perceived the predominant cause of crime to be drugs (N=6 (20%). Here again, the majority were "clubbers" (N=5 (83.3%), while one (16.7%) was a "scrapper." Indeed, it was not uncommon for perceptions of causes of black male criminality to be influenced by personal experiences, however fleeting, as the following clubber's narrative illustrates:

> You see more men getting out there hustling or going to the stores stealing to get their habit, to get their drugs. Selling everything they can, the clothes off their backs. I've seen one man downtown that sold his whole outfit off his body and sold it to the dope fiend. Damn, drugs are that bad
> . . .

This next "clubber" shares another personal story regarding a major drug trafficking case and her husband:

> My husband, he was a dope dealer and he was transporting drugs state to state. And his side of the family and they were involved in drug trafficking and he got caught up in that. Trying to get fast money is basically it. And when you get caught up in the game and the only way you can leave it alone is to go somewhere and get a job and just move away and start over.

Likewise, another "clubber" shares the following intimate details of her life as the wife of a convicted drug dealer:

> Usually it just goes back to feeding our children. A man's reason is usually just out of desperation. With my husband, in the beginning his was materialistic. He just enjoyed having that extra $1,000 just here and there. As he got older, I did notice this change, he was so perfect, and he had the chain . . . In the beginning it was just about cars, clothes, having that image, but as he grew, it became, "I just want to make sure that the kids have this, you know, the kids when they are 18 I can give them some money and they can start off, not having to struggle."

Homies and/or gang was cited by four (13.3%) inmates interviewed. All four were "riders."

> Gang activities . . . Well, you know, I have a little brother who swears he's not gang affiliated, you know, but you know, he's loyal to the hood. And the very first time he ended up in prison, he's been in prison twice, and the first time he took a case that didn't belong to him. The guys went and robbed the place and robbed some people and then they ran to the house and woke him up out of his sleep and said, "Man take such and such home." He gets up and goes to take them home and he drops them off and then he gets stopped in the car. And so he ends up with the case, six years. What do you do, you don't tell, the code, the code on the streets, you just roll with it.

Furthermore, this "rider" also cited gang affiliated ties:

> They were involved in gangs, in a gang, you know. It's called representing . . . representation, how that gang is represented mainstream. You know, playing that role in private, but you ain't got to prove nothing to nobody. Now that I know that, they were just trying to be tough guys.

Moreover, this rider poignantly described her own brother's pathway to gang involvement:

> One brother I know for sure he was being picked on all the time and he was being shot at. He was going to Verbum Dei and then from Verbum Dei he ended up going to Santa Monica College. The Crips used to just shoot at this boy and he would run home crying.

She continues:

> He just got tired. He actually got a gun and started shooting back at these Dudes; he was just trying to go to school. He got tired of basically trying to go to the Catholic school and he just went and got a gun and started gang banging. It made him a much rougher person than the guys who were shooting at him. The anger just builds up. When do you stop beating me down or when do you stand up and fight back?

Likewise, the remaining "scrapper" also describes how gangs circumscribed the lives of not one, but two of her siblings: "Well, I got three brothers and they are all in gang violence and doing prison time behind it."

Noticeably, the category abuse and/or neglect was cited by only one "scrapper" (3.3%). This lifer sums this category up with the following statement:

> From what I see on TV and what I've read, it has to be a very hard situation for a black man today. They didn't feel loved, they didn't know love, they didn't have their basic needs provided for, their parents separated while they were young, they weren't raised right. The same things that affect women affect men but I think it's twice as difficult for men because they are supposed to be the providers, the protectors.

In summary, inmates' perceptions of black men's reasons were mixed. "Riders" were equally divided between the categories (of) low self-esteem, survival, and homies/gangs. Likewise, "clubbers" were almost equally split between the categories of drugs and low self-esteem. Finally, "scrappers" were more likely to identify survival as the root cause of black men's criminality.

Locus of Control for Crimes

In this section I discuss my respondents' perceptions of locus of control in regard to self and others. Specifically, I investigate whether the women are more likely to use internal or external locus of control to explain their own and others' crimes. As noted in chapter three, internal locus of control refers to the belief that one controls one's destiny, while external locus of control refers to the perception that one's fate is determined by chance or forces outside of one's ability to control (Rotter 1973). According to Weiner (1974), perceptions about locus of control among the general public can be divided into internal (personal) factors and external (environmental) causes.

It has long been argued that humans think in terms of dichotomous constructs (internal or external), rather than continua (degree of internality-externality) (Kelly 1955). This study however suggests that respondents' locus of

control is both internal and external. That is, black women inmates identify a combination of both personal and environmental causes. Likewise, participants perceived other black women inmates' locus of control as internal as well as external. Finally, black female offenders perceived white women prisoners' locus of control as both internal and external. These findings indicate that black women offenders themselves have a very different view of themselves and their situation compared to others. This challenges the literature regarding perceptions, which suggests that inmates predominantly view environmental factors as the cause of crime.

Not surprisingly, my results revealed that black female inmates also view black male inmates' locus of control as internal and external. As one inmate so eloquently put it, "It's not one event but a combination of events." It is safe to say that black female inmates do not solely embrace either internal or external dimensions of locus of control. That is, black females inmates do not fully believe in the thesis that one controls one's own destiny nor do they totally accept that control over your life ultimately rests with others. Instead, they opt for a mixture of internal and external locus of control. There are a couple of possible explanations as to why black women inmates might present an exception here. According to Jackman (1994), individualism, the foundation of the American cultural narrative, affects judgments of self and others and encourages the idea of internal locus of control for both self and others. It is quite possible that the American cultural narrative, individualism, does not produce equivalent affects on black women inmates' judgments of self and others. Thus, the American ideology of individualism, rather than promoting individualism among black women inmates, might instead encourage a consciousness that recognizes the validity of both personal and environmental factors more fully. Stated simply, black women's unique structural location in U.S. society gives them less stake in the ideology of individualism. Another possible explanation could be black women's historical legacy surrounding gender, race, and class oppression in society.

Consequences of Attributions About Crime

Next, I will explore how black female inmates compare their hopes and dreams for their future with other women's future hopes and dreams. As stated in chapter three, Gillespie and Galliher (1972) highlight the importance of male inmates' definition of the impact of prison on their prospects for the future. Not surprisingly, informants report becoming more concerned about their future during their incarceration. The overwhelming majority of informants, twenty-nine (96.7%), said they had become more concerned about their future. For instance, one inmate explained the reasons she became more concerned about her future as follows:

> I feel like I have become more concerned about my future because the fog has been lifted and I see life in a different light now. I want to live beyond all of this. Everybody is better now. I'm better now. I want to open a business, a Christian bookstore, where you have gospel aerobics and young and old people can come.

Another participant put it this way:

> I think I became very concerned, no more conscious, not concerned. I have so much to give. I have so much I want out of life. I took a lot of things for granted.

Only one inmate (3.33%) reported becoming less concerned about the future during her incarceration. When informants were asked what are their hopes and dreams for the future, fourteen (46.7%) said they intended to reunite with loved one(s) (e.g., family members or blood relatives such as children, siblings, parents, and spouses and fictive kin such as friends, and significant others). For example, when the aforementioned woman was asked about her hopes and dreams for the future, she just wanted to be there for her loved one(s):

> I want to be there for the birth of my grandchildren and make up for lost time. I also want to be there for my mother and my daughter. I just want to

be there, I just want to be there. I also want to be an advocate for people like me who struggle with drugs and addiction.

Another woman shared her hopes and dreams for the future:

I just want to enjoy life and enjoy my mother mainly. She's 60 years-old. So I just want to get us back together and be a family and contact my father; just living life, nothing extravagant. Even a shack would be okay. I just want to live life in a more family like way.

In fact, reuniting with family was a priority for almost half of respondents, as the following quote reveals:

I came here behind my brother. I know I made a decision for whatever I did. I'm going to support him no matter what. As soon as I get out, back to my family, I'm going to help get him an appeal.

Similarly, this quote also illustrates the predominant theme of reunification with family:

I have a lot of sense. That's something that people don't really know. I have a lot of things that I want to do when I go home. One of the main things is to be a mother.

Moreover, sixteen women (53.3%) said they intended to pursue a law abiding lifestyle. In fact, several expressed interest in drug and alcohol counseling as well as the human services and mental health professions: "Working with kids and a counselor for a drug program, I want to be a youth advocate. I want to become a drug counselor, reaching out and helping counsel kids." The following comments were typical of this group of inmates:

I want to live a productive life as soon as I get out of CIW. I want to get a real job and spend time with my mom. And I want to do simple things, like get a credit card in my name and sign a lease for an apartment. I want to pay a bill legally.

Another inmate had this to say:

> I'm looking forward to getting out. I never had a job, worked, or had my own place. That's why I'm going straight to a sober living home.

When asked about other black women inmates' perceived future hopes and dreams, the majority of informants (N=25 (83.3%) believed that their hopes and dreams are similar to other black women inmates future hopes and dreams. Informants overwhelmingly mentioned lawfulness (N=14 (46.7%), but also mentioned reunification with loved one(s) (N=12 (40%), and unlawfulness (N=4 (13.3%). In regard to white women offenders' hopes and dreams, informants mentioned lawfulness (N=11 (36.7%), unlawfulness (N=10 (33.3%), and reunification with family (N=9 (30%). In regard to other women offenders' hopes and dreams, inmates mentioned lawfulness (N=10 (33.3%) and reunification with family (N=20 (66.7%). Finally, in regard to black male offenders' hopes and dreams, inmates mentioned lawfulness (N=9 (30%), unlawfulness (N=12 (40%), and reunification with family (N=9 (30%).

In summary, black women inmates identify primarily with two (2) types of attributions regarding perceptions of their own criminality: external (loved one(s)) and internal/external (drugs). Additionally, black female prisoners mentioned one (1) type of attribution in regard to other black women prisoners' criminal behavior: internal/external (drugs). Moreover, black female offenders identified two (2) types of attributions in regard to white women: internal (low self-esteem) and internal/external (drugs). Respondents cite one (1) type of attribution regarding other female offenders' behavior: internal/external (drugs). The women also mentioned two (2) types of attributions for black men's behaviors: internal (low self-esteem) and external (survival). Finally, black women inmates' locus of control is both internal and external.

CHAPTER SIX:
DISCUSSION AND IMPLICATIONS

In this chapter I will discuss the major implications of this research project. Furthermore, I will offer suggestions for future research in regard to women and crime. This study employed a qualitative analysis of thirty (30) in-depth, semi-structured interviews to analyze black female offenders' perceptions of what causes crime as well as their orientation toward the future. The study drew upon the social psychological approach known as attribution theory (Heider 1958; Ross and Nisbett 1991) and on the sociological work concerned with how people account for their behaviors, especially behaviors unlikely to be approved in their society (Scott and Lyman 1968). The research questions were: (1) Do black female inmates make more internal or external attributions in regard to their crimes? (2) Do black female inmates make more internal or external attributions in regard to others crimes? (3) What are black female inmates' hopes and dreams for their future? (4) How do black female inmates compare their hopes and dreams for their future with other women's future hopes and dreams?

The interviews with black female inmates in this study provide important insights into women's perceptions of causes of crime as well as their hopes and dreams for their future. According to Mathis and Rayman (1972), male inmates identify external, environmental factors as one of the primary causes of crime. Black women inmates identify two (2) types of attributions when asked about the causes of black men's crimes: internal (low self-esteem) and external (survival).

Thus, these findings suggest that the gender of the perceiver affect causal attributions about crime. Contrary to the literature, social structural attributions were more common than individualistic ones. Additional analysis indicates that the women tend to attribute black men's crime to unfortunate or unjust circumstances.

In contrast, the black female offenders in this study identified two (2) types of attributions in regard to their own criminality: external (loved one(s)) and internal/external (drugs). Moreover, black women inmates identified one (1) type of attribution when asked about the causes of other black women inmate's crimes: internal/external (drugs). Another finding was that the inmates identified two (2) types of attributions when asked about the causes of white women inmates' crimes: internal (self-esteem) and internal/external (drugs). Additionally, black women inmates identified one (1) type of attribution when asked about the causes of other (Hispanic and Asian) women inmates' crimes: internal/external (drugs). My study would therefore indicate that their perceptions differ according to the race of the offender. My work suggests the strong influence of race in regard to the perceiver and the perceived. The vast majority of "clubbers" attribute their and other's criminality to drugs. Previous research has suggested that a number of factors—gender, culture, status—influence perceptions. My research offers further support for these findings by adding the dimension of race. That is, black women offenders judge the crimes of other black offenders differently from the crimes of white and other women offenders. Therefore, it is safe to say, the distinction that attribution theorists make between attributions concerning self and others is complicated by the race of the others. The race of others affects the ways in which those others are perceived and judged.

Overall, the interviews examined here suggest that black female inmates invoke a complex combination of internal and external attributions for their behavior as well as the behavior of others. As stated earlier, causal attributions have important implications for the future lives of offenders. As stated in Chapter three, drug use may originate in external causes, but become the internal cause of

subsequent behaviors. Thus, the category drugs is both an internal and external factor. Because drugs were mentioned by a majority of informants, and because drugs are frequently cited in research on women and crime, my findings support recent research in which both internal and external factors are given equal weight in the causes. Furthermore, this research incorporated two approaches to the study of women and crime (e.g. social attributions and pathways). Specifically, this research sought to take a more sociological approach to the examination of causal attributions. In addition, this approach places women, in this case black women, at the center of analysis and focuses on their perceptions of what causes crime.

What, then, can we conclude about black female inmates' perceptions of what causes other women's and men's criminality? The black women studied here, similar to Chesney-Lind (1997), Richie (1996), and Owen (1998), identify distinct paths that characterized women's and men's entry into situations that lead to incarceration. These findings suggest that while male offenders cite primarily external attributions in regard to their crimes, black women inmates cite a mixture of attributions: internal, external, and internal/external. Thus, a somewhat more complex pattern emerged for black women inmates' perceptions of their own as well as other offenders' criminality. Therefore, it is safe to say that black female inmates perceived a range of circumstances that help pave both women's and men's ways into crime. Previous research confirms that a number of paths to crime exist for women—drug use, membership of domestic networks, domestic violence, intimate relationships, childhood abuse and/or neglect, and poverty (Richie 1996; Gilfus 2006). Findings such as these led Comack (1996) to argue that women's law-breaking is best characterized as typologies of behavior that represent an outgrowth of the "problems, conflicts, and dilemmas" that women experience in everyday life. My study appears to confirm this. The question remains, however, why do black women see black men's problems, conflicts, and dilemmas as more complex than they view their own?

The major contribution of this study has been the focus on racialized attributions about crime. As stated earlier, racialized attributions refer to the ways

in which the race of the perceived affects the perceiver. While black female inmates perceived external and internal/external causes for their own behavior, they perceived internal and internal/external causes in regard to white women's crimes. Additionally, black female inmates perceived internal/external causes in regard to other women's crimes. Black female inmates did perceive drugs, an internal/external factor, as one of the predominate causes of all women's situations. Gendered attributions about crime were also examined. Black female offenders mentioned two (2) types of attributions for black men's crimes: internal and external. These findings suggest that black female inmates are more likely to focus on a myriad of social and interpersonal circumstances faced by both female and male offenders.

Regarding another issue, my findings support research by Gillespie and Galliher (1972) which suggests that inmates become more concerned about their future during incarceration. As already noted, their study is relevant to mine because it draws attention to the consequences of male and female inmates' definitions of themselves and their situations for their optimism about the future. Surprisingly, both lifers and short-termers anticipate having a future outside of prison. Thus, women serving life-sentences and women facing the possibility of parole were equally as optimistic about their future. Similar to Gillespie and Galliher (1972), my interpretation of this optimism is that black women inmates view their incarceration as ultimately temporary. In fact, several inmates even reported knowing lifers who were eventually released from prison (i.e., pardoned by the governor). Another possible interpretation of these findings, although not studied in this study, involves the role of black women's religious faith. It is possible that black women inmates' strong emphasis on optimism might reflect a strong religious faith. This interpretation has merit in light of the current studies that report significant religious involvement among black women (Sullivan 2006).

There are some limitations to this study. The findings are based on a purposive sample comprised of black female inmates incarcerated at the California Institution for Women. Although bias is eminent in purposive samples,

it is useful to provide in-depth analysis of subject matter. Likewise, bias is a concern as this is self-report data. It is quite possible that inmates said what they thought I wanted to hear rather than what they believed. Thus, inmates might have felt compelled to provide socially desirable responses to appear rehabilitated in the eyes of parole boards. According to feminist research methods, the accuracy of an interview concerns the substance or the meaning of the interview. Maxwell (1996: 58) sums this issue up with the following statement:

> the real interest is in how participants make sense of what has happened, and how this perspective informs their actions, rather than determining precisely what they did.

While it is true that the trustworthiness of interviews cannot be guaranteed here, all admissions contained in this study are thought to be truthful and honest. Thus, the findings may not be generalized to all black women that are currently serving time in our jails and prisons. Moreover, the findings may not be applicable to white or other female inmates. Finally, this sample was restricted to a non-random sample of black female inmates. The limitations of this study indicate the need for further research in the area of women's perceptions of what causes crime. Samples of white, Hispanic, and Asian female inmates would add to our understanding of women's perceptions of what causes crime. Moreover, this might help to yield results that are generalizable to all women prisoners.

In conclusion, by examining black women inmates' perceptions of what causes crime, this study reveals the complexity of individuals' attributions for their criminal behavior as well as criminal behavior of others. Of particular importance is the internal/external dimension as a perceived predominant cause of crime. Thus, this study reveals that there are important dimensions to inmates' perceptions of what causes crime that other studies have left out. In short, these inmates' perceptions of what causes crime are consistent with research on women's paths to crime. Furthermore, these findings support research on female criminality that suggests that women have numerous paths to crime.

APPENDIX 1

Operational Definitions of Coding Categories

V1. *Interview Number*—the interview number was assigned by the researcher to ensure that each interview was accounted for.

V2. *Childhood*—content concerned with perceptions of early life experiences while growing up America. This category includes childhood and adolescent experiences. The variable "childhood" has the following categories: not mentioned, happy, unhappy, and uncertain.

V3. *Delinquency Reasons*—content concerned with perceptions of initial involvement in delinquent behavior when younger. The variable "delinquency" has the following categories: abuse/neglect, drugs, low-self-esteem, survival, loved one(s), homies/gang, and other. The category abuse/neglect includes content regarding verbal, physical and sexual abuse. Additionally, the category abuse/neglect includes content referencing fear, violent confrontations, and use of weapons. The category low self-esteem includes content about greed, pride, respect, anger, boredom and fun. The category survival includes content referring to struggling to survive and money woes. The category loved one(s) includes family members or blood relatives such as children, siblings, parents, and spouses and fictive kin such as friends, and significant others.

V4. *Current Case1*—content concerned with convictions for criminal activity which involves drugs-related offenses such as sale or use of stimulants, hallucinogens, opioids, depressants, and cannabis. Current Case1 has the following categories: not mentioned, drug-related, not drug-related, and uncertain.

V5. *Current Case2*—content concerned with convictions for criminal activity which involves violent (battery, assault, murder, rape, child molestation) crimes. Current Case2 has the following categories: not mentioned, violent, non-violent and uncertain.

V6. *Current Case3*—content concerned with convictions for criminal activity which involves white-collar offenses such as identity theft, embezzlement,

forgery, check kitting, or credit card fraud. Current Case3 was divided into the categories of not mentioned, white-collar, not white-collar, and uncertain.

V7. *Important Reasons*—content concerned with perceptions of the circumstances or experiences which led to the activity and subsequent incarceration. The variable "important reasons" has the following categories: abuse/neglect, drugs, low-self-esteem, survival, loved one(s), homies/gang, and other. The category abuse/neglect includes content regarding verbal, physical and sexual abuse. Additionally, the category abuse/neglect includes content referencing fear, violent confrontations, and use of weapons. The category low self-esteem includes content about greed, pride, respect, anger, boredom and fun. The category survival includes content referring to struggling to survive and money woes. The category loved one(s) includes family members or blood relatives such as children, siblings, parents, and spouses and fictive kin such as friends, and significant others.

V8. *Black women Unique Reasons*—content concerned with perceptions of whether or not black women have unique reasons for being involved in activities that lead them to prison. This variable has the following categories: not mentioned, unique, not unique, and uncertain.

V9. *Other Black Women's Reasons*—content concerned with perceptions of black women's reasons for being involved in situations that led them to prison. The variable "other black women's reasons" has the following categories: abuse/neglect, drugs, low-self-esteem, survival, loved one(s), homies/gang, and other. The category abuse/neglect includes content regarding verbal, physical and sexual abuse. Additionally, the category abuse/neglect includes content referencing fear, violent confrontations, and use of weapons. The category low self-esteem includes content about greed, pride, respect, anger, boredom and fun. The category survival includes content referring to struggling to survive and money woes. The category loved one(s) includes family members or blood relatives such as children, siblings, parents, and spouses and fictive kin such as friends, and significant others.

V10. *Similar/Different Reasons1*—content concerned with comparing your reasons with other black women's reasons. The variable "similar/different reasons" has the following categories: not mentioned, similar, different, and uncertain.

V11. *Similar/Different Reasons2*—content concerned with comparing reasons with white women's reasons. The variable "similar/different reasons" has the following categories: not mentioned, similar, different, and uncertain.

V12. *White Women's Reasons*—content concerned with perceptions of white women's reasons for being involved in situations that led them to prison. The variable "white women's reasons" has the following categories: abuse/neglect, drugs, low-self-esteem, survival, loved one(s), homies/gang, and other. The category abuse/neglect includes content regarding verbal, physical and sexual abuse. Additionally, the category abuse/neglect includes content referencing fear, violent confrontations, and use of weapons. The category low self-esteem includes content about greed, pride, respect, anger, boredom and fun. The category survival includes content referring to struggling to survive and money woes. The category loved one(s) includes family members or blood relatives such as children, siblings, parents, and spouses and fictive kin such as friends, and significant others.

V13. *Similar/Different Reasons3*—content concerned with comparing reasons with other women's reasons. The variable "similar/different reasons" has the following categories: not mentioned, similar, different, and uncertain.

V14. *Other Women's Reasons*—content concerned with perceptions of other women's (Hispanic, Asian, Native American) reasons for being involved in situations that led them to prison. The variable "other women's reasons" has the following categories: abuse/neglect, drugs, low-self-esteem, survival, loved one(s), homies/gang, and other. The category abuse/neglect includes content regarding verbal, physical and sexual abuse. Additionally, the category abuse/neglect includes content referencing fear, violent confrontations, and use of weapons. The category low self-esteem includes content about greed, pride,

respect, anger, boredom and fun. The category survival includes content referring to struggling to survive and money woes. The category loved one(s) includes family members or blood relatives such as children, siblings, parents, and spouses and fictive kin such as friends, and significant others.

V15. *Similar/Different Reasons4*—content concerned with comparing reasons with black men's reasons. The variable "similar/different reasons" has the following categories: not mentioned, similar, different, and uncertain.

V16. *Black Men's Reasons*-- content concerned with perceptions of black men's reasons for being involved in situations that led them to prison. The variable "black men's reasons" has the following categories: abuse/neglect, drugs, low-self-esteem, survival, loved one(s), homies/gang, and other. The category abuse/neglect includes content regarding verbal, physical and sexual abuse. Additionally, the category abuse/neglect includes content referencing fear, violent confrontations, and use of weapons. The category low self-esteem includes content about greed, pride, respect, anger, boredom and fun. The category survival includes content referring to struggling to survive and money woes. The category loved one(s) includes family members or blood relatives such as children, siblings, parents, and spouses and fictive kin such as friends, and significant others.

V17. *Similar Situations*—content concerned with whether or not you're aware of other women similarly situated but not incarcerated.

V18. *Do Over*—content concerned with whether or not you would do things differently. "Yes" denotes that things would be done differently while "no" signifies that things would do.

V19. *Concern About Future*—content concerning whether more or less concerned about the future. "Yes' denotes more concerned while "no" signifies less.

V20. *Hopes and Dreams*—content concerned with future hopes and dreams. The variable "hope and dreams" has the following categories: not mentioned, reunification with loved one(s), lawfulness, unlawfulness, and other. The category reunification with loved one(s) includes family members or blood relatives such

as children, siblings, parents, and spouses and fictive kin such as friends, and significant others. The category lawfulness includes prioritizing basic needs such as education, employment, and shelter. Additionally, lawfulness involves prioritizing sobriety for many of the volunteers. The category unlawfulness includes such activities as getting high and other criminal activities that led to prison.

V21. *Do With Your Life*—content concerned with future. The variable "do with your life" has the following categories: not mentioned, reunification with loved one(s), lawfulness, unlawfulness, and other. The category reunification with loved one(s) includes family members or blood relatives such as children, siblings, parents, and spouses and fictive kin such as friends, and significant others. The category lawfulness includes prioritizing basic needs such as education, employment, and shelter. Additionally, lawfulness involves prioritizing sobriety for many of the volunteers. The category unlawfulness includes such activities as getting high and other criminal activities that led to prison.

V22. *Similar/Different Hopes and Dreams*—content concerned with comparing future hopes and dreams with other black women's future hopes and dreams. The variable "similar/different hopes and dreams" has the following categories: not mentioned, similar, different, and uncertain.

V23. *Black women's Hopes and Dreams*—content concerned with future hopes and dreams. The variable "hope and dreams" has the following categories: not mentioned, reunification with loved one(s), lawfulness, unlawfulness, and other. The category reunification with loved one(s) includes family members or blood relatives such as children, siblings, parents, and spouses and fictive kin such as friends, and significant others. The category lawfulness includes prioritizing basic needs such as education, employment, and shelter. Additionally, lawfulness involves prioritizing sobriety for many of the volunteers. The category unlawfulness includes such activities as getting high and other criminal activities that led to prison.

V24. *Similar/Different Hopes and Dreams*—content concerned with comparing

future hopes and dreams with white women's future hopes and dreams. The variable "similar/different hopes and dreams" has the following categories: not mentioned, similar, different, and uncertain.

V25. *White Women's Hopes and Dreams*—content concerned with future hopes and dreams. The variable "hope and dreams" has the following categories: not mentioned, reunification with loved one(s), lawfulness, unlawfulness, and other. The category reunification with loved one(s) includes family members or blood relatives such as children, siblings, parents, and spouses and fictive kin such as friends, and significant others. The category lawfulness includes prioritizing basic needs such as education, employment, and shelter. Additionally, lawfulness involves prioritizing sobriety for many of the volunteers. The category unlawfulness includes such activities as getting high and other criminal activities that led to prison.

V26. *Most Affect*—content concerned with things learned and experienced while at CIW that would have the most affect in the years to come. The variable "most affect" has the following categories: not mentioned, incarceration, programming, discipline, social relationships, and other.

APPENDIX 2

Attention: Research Project Interviews

Recruitment Flyer

Hello, my name is La Tanya Skiffer and I am a graduate student at the University of Missouri-Columbia. I am interested in interviewing African American women about their ideas of what causes crime as well as their hopes and dreams for the future. I am looking to interview thirty (30) women at your institution and interviews will be conducted between March 7, 2006 and July 3, 2006. Participation will take approximately two (2) hours of your time. If you are interested in participating in this project, please sign-up on the sign-up sheet. Please note that there is a chance that you may or may not be chosen to participate in this study. Thank you for your interest in my project!

APPENDIX 3
BACKGROUND AND DEMOGRAPHICS:
Please complete the following background and demographic information.

1. Age: _____

2. Race: _____

3. Marital Status: **S**ingle **M**arried **D**ivorced **SE**parated **C**ohabitating Partnership

4. Parental Status (Number of Children): _____

5. Age of Children: (1^{st} Child) _____ (2nd) _____ (3^{rd}) _____ (4^{th}) _____ (5^{th}) _____ (6^{th}) _____

6. Who cares for your dependent (under 18) children? _____

7. Education: **L**ess than high school **H**igh school grad **GED S**ome college Four-year college degree

8. Mother's Job/Occupation: _____

9. Father's Job/Occupation: _____

10. Arrest(s) _____

11. Conviction(s) (List Type of Convictions): _____

12. Sentence(s) (List Sentences You Have Served): _____

13. Treatment History (List Treatment Programs You Participated:

 a. Before Prison: _____

 b. In Prison: _____

APPENDIX 4

<u>Consent Form</u>

Hi, I am La Tanya and I will be talking to you about your views on what causes crime. This is a research project. This will take about two (2) hours. I will talk to 30 women at CIW. This is an interview and not an experiment. La Tanya (the researcher) can stop your participation at any time without your consent.

Let me tell you what I want to talk to you about, your part in it, risks to you, and how to contact me and my supervisors.

<u>Project Title: Views and Perceptions of What Causes Crime: The Case of Black Female Offenders in Correctional Systems.</u>

During our talk, you will be asked the following questions:

- How and why you came to be in jail at CIW?
- How you compare your reason(s) for committing crime with the reason(s) other black women at CIW became criminals?
- How you compare your reason(s) for committing crime with the reason(s) other white women at CIW became criminals?
- Your hopes and dreams for your future?
- How your hopes and dreams for your future compare with other black and white women's future hopes and dreams at CIW?

<u>Risks to You</u>

Although you will **NOT** be harmed during our talk, there are some risks that you should be aware of in order for you to decide whether or not to participate. First, the risk that you will disclose information about past criminal behavior. Second, that you will disclose information about future criminal behavior. Third, that you will become emotionally distressed. Fourth, that you will express intent to harm yourself or others during the interview. There may also be some unforeseeable risks with to you.

<u>Benefits to You</u>

By participating in this study you will have an opportunity to help researchers and policy makers learn from and understand some of the most difficult experiences of your life as well as give voice to the internal changes you have undone while incarcerated. Furthermore, you will have an opportunity to help increase our social understanding of African American women's real life experiences. The information that you provide will go far in enhancing society's understanding of the factors that contribute to the likelihood of incarceration of African American women over the life course.

Alternatives

There are alternative ways to participate. First, you can agree to participate at a later date. Second, you can write a letter to Ms. Skiffer and share your life experiences. Finally, you can have a telephone conversation with Ms. Skiffer about your perception of causes of crime.

Confidentiality

The information from our talk will be kept confidential, under lock and key. No one will know your real name. Your talk will only be recorded if you agree. You do **NOT** have to talk about anything you do not want to talk about. You may stop talking at any time. Only the typist will hear our talk but she will not know your real name. The typist will return all of the tapes when the typing is completed. The typist will return everything to La Tanya (notes, disks). The typist computer files will be deleted. What you say will **NOT** affect your parole status.

How to Contact Us

During our talk, you will receive a Phone card. Use this Phone card to call me if you have questions about the research. Use the Phone card to call my supervisors if you have questions about your rights or research related injury. La Tanya can be reached at (xxx-xxx-xxxx). Dr. John Galliher (Supervisor) at (xxx-xxx-xxxx). Dr. Ibitola Pearce (Supervisor) at (xxx-xxx-xxxx). You can also call the University of Missouri-Columbia Institutional Review Board at (573) 882-9585 your rights or research related injury. If you do not have questions, please keep the Phone card!

Pre-Addressed/Stamped Envelopes

You will also get four (4) pre-addressed envelopes in the mail. Please use the envelopes to write to me, my supervisors, or the Institutional Review Board if you have additionally questions.

Start and End Date

La Tanya will conduct interviews between March 7, 2006 and July 3, 2006.

Consent

I have read and understand this form and I agree to speak with La Tanya. I understand that my participation is voluntary and I can refuse to participate or withdraw from the project at anytime with no penalty or loss of benefits. I know that my parole status will **NOT** change.

Name:_____ Date:_____

Please send me a copy of the project results. (check here) _____.

APPENDIX 5

Oral Script

Hello my name is La Tanya Skiffer.

Identification	As part of my research I am conducting a study of African American women in correctional systems.
Purpose	The purpose of this study is to gain an understanding of the causes of crime from the perspective of African American female inmates.
Protection of Privacy	Confidentiality of you as a volunteer and your responses will be protected throughout this study and publication. With your permission the interview will be recorded and later transcribed. You do not have to answer any questions you do not want to answer, and at any time you may stop the interview and speak off the record and still be able to continue with the interview if you like.
Voluntary Participation	Participation in this study is voluntary and, as stated earlier, you can stop answering any or all questions without penalty or explanation at any time. Please understand that your responses are appreciated and will be helpful in my research. It is estimated that your interview will take approximately two (2) hours. Your participation will involve being interviewed in person and authorizing me to tape your interview. At any time, you may withdraw from the study by simply indicating to that you would like to do so. All tapes and notes from your interview will then be immediately destroyed.
Contact	If you have any questions or comments concerning this study, you can contact me at (xxx-xxx-xxxx) or my faculty advisors, Dr. John Galliher at (xxx-xxx-xxxx) and Dr. Ibitola Pearce at (xxx-xxx-xxxx). This research was approved by The Institutional Review Board for The Protection of Human Subjects at The University of Missouri-Columbia, (573) 882-9585. Thank you for your help.

APPENDIX 6

VIEWS AND PERCEPTIONS OF WHAT CAUSES CRIME:
THE CASE OF BLACK FEMALE OFFENDERS

SEMI-STRUCTURED INTERVIEW QUESTIONNAIRE – Spring, 2006

First, on tape enter respondent's ID Number and the day, date, and time of the interview.
To introduce interview, go over informed consent form, stressing three things.

(1) What the interview is about:

I AM GOING TO BE ASKING YOU SOME QUESTIONS ABOUT HOW AND WHY YOU CAME TO SERVE TIME IN PRISON. I AM INTERESTED IN KNOWING WHAT YOUR EXPERIENCES HAVE BEEN AND WHAT YOU REALLY THINK CAUSES CRIME.

(2) The interview is safe and confidential:

ALTHOUGH YOU WILL <u>NOT</u> BE HARMED DURING OUR TALK, THERE ARE SOME RISKS TO YOU. THE INFORMATION FROM OUR TALK WILL BE KEPT CONFIDENTIAL, UNDER LOCK AND KEY. NO ONE WILL KNOW YOUR REAL NAME. YOUR TALK WILL ONLY BE RECORDED IF YOU AGREE. ONLY THE TYPIST WILL HEAR OUR TALK BUT EVEN SHE WILL NOT KNOW WHO YOU ARE. THE TYPIST WILL RETURN ALL OF THE TAPES WHEN THE TYPING IS COMPLETED. THE TYPIST WILL RETURN EVERYTHING TO LA TANYA (NOTES, DISKS). THE TYPIST COMPUTER FILES WILL BE DELETED. ARE TALK WILL BE PRIVATE. WHAT YOU SAY WILL <u>NOT</u> AFFECT YOUR PAROLE STATUS.

(3) They have the right to ask questions:

BEFORE I TURN ON THE TAPE RECORDER AND BEGIN THE INTERVIEW, DO YOU HAVE ANY QUESTIONS YOU WANT TO ASK ME ABOUT THE PROJECT?

Make sure that respondent signs consent form before interview begins.

<u>Interview</u>

Q-1. LET'S START BY TALKING ABOUT YOUR LIFE EXPERIENCES WHILE GROWING UP. WOULD YOU SAY YOU HAD A NORMAL CHILDHOOD BY AMERICAN STANDARDS?
Probe to get full information: WAS IT HAPPY?

If the respondent wants a definition of "experiences," say that they could include events, or people and relationships, or achievements, or feelings that the respondent had during the years. The experience could have happen during childhood, the teens, twenties, etc.

If the respondent alludes to an experience in an unclear or terse manner, probe for more details by saying things like: PLEASE TELL ME MORE ABOUT THAT? WHY WAS THAT EXPERIENCE IMPORTANT FOR YOU?

Q-2. NOW TELL ME HOW YOU FIRST GOT INVOLVED IN SO CALLED BAD/DELIQUENT BEHAVIOR WHEN YOU WERE YOUNGER? Probe to get full information: WAS THERE AN EVENT THAT STARTED YOU ON THIS PATH?
If the respondent alludes to an experience in an unclear or terse manner, probe for more details by saying things like: WERE YOU ABUSED OR NEGLECTED BY ANYONE? WERE YOU INVOLVED IN DRUGS, VIOLENT CONFRONTATIONS, WEAPONS, OR GANGS AT ANYTIME FROM YOUR TEENS TO THE TIME BEFORE YOU WERE FIRST INCARCERATED? WHAT WAS THE SITUATION LIKE?

Q-3. After respondent has no more information to give about her life experiences…
PLEASE TELL ME HOW YOU FIRST GOT INVOLVED IN CRIME?
Probe to get full information: HOW OLD WERE YOU? DID SOMETHING HAPPEN TO YOU, LIKE AN EVENT?

Q-4. After respondent has no more information to give about how she got involved…
NOW TELL ME HOW YOU CAME TO BE IN JAIL AT CIW? If no mention is made about drugs, ask: WERE DRUGS INVOLVED IN YOUR CASE?

Q-5. IF YOU THINK BACK OVER THE CIRCUMSTANCES SURROUNDING THE LENGTH OF YOUR CURRENT CONVICTION, WHAT ARE THE CIRCUMSTANCES OR EXPERIENCES THAT STAND OUT AS IMPORTANT REASON(S) THAT LED YOU TO THAT ACTIVITY?
Probe to get full information: WHAT WAS ON YOUR MIND WHEN YOU GOT INVOLVED IN THAT SITUATION? WHAT WAS IMPORTANT

TO YOU? WHAT WAS GOING ON IN YOUR LIFE?

If respondent alludes to an experience in an unclear or terse manner, probe for more information by saying such things as: PLEASE TELL ME MORE ABOUT THAT? WHY WAS THAT AN IMPORTANT REASON FOR BEING IN THAT SITUATION FOR YOU?
General Probe: ARE THERE OTHER EXPERIENCES THAT WOULD EXPLAIN YOUR REASON(S) FOR BEING IN THAT SITUATION?

Q-6. After respondent has no more information to give about experiences....
HOW WOULD YOU EXPLAIN OTHER BLACK WOMEN AT CIW REASON(S) FOR BEING INVOLVED IN THE ACITIVITY THAT LED THEM TO PRISON?
Probe to get full information: ARE THERE UNIQUE REASONS BLACK WOMEN GET INVOLVED IN ACTIVITIES FOR WHICH THEY ARE PUT IN PRISON? CAN YOU GIVE ME AN EXAMPLE OF A BLACK WOMAN'S REASON(S) FOR BEING IN CIW?
If respondent alludes to a reason(s) in an unclear or terse manner, probe for more information by saying such things as: WHAT KINDS OF REASON(S) FOR BEING INVOLVED IN THE SITUATION(S) HAVE BLACK WOMEN TALKED ABOUT? WHAT WAS ON THEIR MINDS WHEN THEY GOT INVOLVED IN THAT SITUATION? WHAT WAS IMPORTANT TO THEM?

Q-7. DID YOU GET INVOLVED IN THE SITUATION(S) THAT LEAD YOU TO PRISON FOR THE SAME REASON(S) OTHER BLACK WOMEN GOT INVOLVED IN SITUATIONS THAT LED THEM TO PRISON?
Probe to get full information: CAN YOU PROVIDE AN EXAMPLE?

Q-8. ARE BLACK WOMEN AND WHITE WOMEN'S REASON(S) FOR BEING INVOLVED IN SITUATIONS THAT LEAD THEM TO PRISON SIMILAR OR DIFFERENT? CAN YOU PROVIDE AN EXAMPLE?

Q-9. WHAT KINDS OF REASONS FOR BEING INVOLVED IN THE ACTIVITY THAT LED THEM TO PRISON HAVE WHITE WOMEN AT CIW TALKED ABOUT?
Probe to get full information: WHAT WAS ON THEIR MINDS WHEN THEY WERE INVOLVED IN THAT SITUATION? WHAT WAS IMPORTANT TO THEM? WHAT REASON(S) HAVE YOU HEARD THEM TALK ABOUT?

Q-10. DO BLACK WOMEN GET INVOLVED IN SITUATIONS THAT LEAD THEM TO PRISON FOR THE SAME REASON(S) OTHER WOMEN GET INVOLVED IN SITUATIONS THAT LEAD THEM TO PRISON?
Probe to get full information: CAN YOU PROVIDE AN EXAMPLE?

Q-11. ARE BLACK WOMEN AND BLACK MEN'S REASON(S) FOR BEING INVOLVED IN SITUATIONS THAT LEAD THEM TO PRISON SIMILAR OR DIFFERENT? CAN YOU PROVIDE AN EXAMPLE?

Q-12. WHAT KINDS OF REASONS FOR BEING INVOLVED IN THE ACTIVITY THAT LED THEM TO PRISON HAVE YOU HEARD BLACK MEN TALK ABOUT?
 Probe to get full information: WHAT WAS ON THEIR MINDS WHEN THEY WERE INVOLVED IN THAT SITUATION? WHAT WAS IMPORTANT TO THEM?

Q-13. DO YOU KNOW WOMEN WHO HAVE BEEN INVOLVED IN SIMILAR SITUATIONS BUT HAVE NOT BEEN JAILED?
 Probe to get full information: PLEASE TELL ME MORE ABOUT THAT SITUATION.

Q-14. IF YOU COULD DO IT ALL OVER AGAIN, IS THERE ANYTHING YOU WOULD DO DIFFERENTLY?

Q-15. DURING YOUR TIME IN CIW DO YOU THINK YOU BECAME MORE OR LESS CONCERNED ABOUT YOUR FUTURE? WHY?

Q-16. WHAT ARE YOUR HOPES AND DREAMS FOR YOUR FUTURE?

Q-17. WHAT DO YOU WANT TO DO WITH YOUR LIFE?

Q-18. ARE YOUR HOPES AND DREAMS FOR YOUR FUTURE SIMILAR OR DIFFERENT THAN OTHER BLACK WOMEN'S FUTURE HOPES AND DREAMS IN CIW?

Q-19. ARE YOUR HOPES AND DREAMS FOR YOUR FUTURE SIMILAR OR DIFFERENT THAN WHITE WOMEN'S FUTURE HOPES AND DREAMS AT CIW? CAN YOU PROVIDE AN EXAMPLE?

Q-20. OF ALL THE THINGS YOU'VE LEARNED AND EXPERIENCED DURING YOUR TIME AT CIW, WHAT DO YOU THINK WILL HAVE THE MOST EFFECT ON YOUR LIFE IN THE YEARS TO COME?

Q-21. AND THE VERY LAST QUESTION I HAVE TO ASK YOU IS WHETHER THERE IS ANYTHING ELSE YOU WANT TO TELL ME ABOUT WHY YOU CAME TO BE INVOLVED SITUATIONS THAT LED YOU PRISON OR YOUR LIFE EXPERIENCES?

THANK YOU VERY MUCH FOR YOUR COOPERATION.

At this point, the tape recorder can be turned off, and the respondent should be asked to complete the compensation form.

REFERENCES

Albonetti, Celesta A. 1991. "An Integration of Theories to Explain Judicial Discretion." *Social Problems* 38: 247-266.

Albonetti, Celesta A. 1991. "An Integration of Theories to Explain Judicial Discretion." *Social Problems* 38: 247-266.

Albonetti, Celesta A. and John R. Hepburn. 1996. "Prosecutorial Discretion to Defer Criminalization: The Effects of Defendant's Ascribed and Achieved Status Characteristics." *Journal of Quantitative Criminology* 12: 63-81.

Ammons, Linda L. 1995. "Mules, Madonnas, Babies, Bathwater, Racial Imagery and Stereotypes: The African American Woman and the Battered Woman Syndrome." *Wisconsin Law Review* 5: 1003-1080.

Anderson, Elijah. 2002. "The Code of the Streets". Pp. 295-305 in *African American Classics in Criminology & Criminal Justice*, edited by S. Gabbidon, H. Greene, and V. Young. Thousand Oaks: Sage Publications.

Arnold, Regina A. 1990. "Women of Color: Processes of Victimization and Criminalization of Black women." *Social Justice* 17: 153-166.

Auerbach, Carl F. and Louise B. Silverstein. 2003. *Qualitative Data: An Introduction to Coding and Analysis.* New York: New York University Press.

Babcock, Linda and Sara Laschever. 2003. *Women Don't Ask: Negotiation and the Gender Divide*. Princeton: Princeton University Press.

Bae, Hyunjung and Kathleen S. Crittenden. 1989. From Attributions to Dispositions; Explaining the Attributional Patterns of Korean Students. *Journal of Social Psychology* 129: 481-489.

Bailey, Amanda and Joseph Hayes. 2006. "Who's in Prison: The Changing Demographics of Incarceration." Public Policy Institute of California, August 1. Retrieved September 17, 2006 (http://www.ppic.org/content/pubs/cacounts/CC_806ABCC.pdf)

Bank, Barbara J. 1995. "Gendered Accounts: Undergraduates Explain Why They Seek Their Bachelor's Degrees." *Sex Roles*, 32:527-544.

Becker, Gary S. 1963. *Outsiders: Studies in the Sociology of Deviance.* New York: Macmillan.

Becker, Gary S. 1974. "Crime and Punishment: An Economic approach". In *Essays in the Economics of Crime and Punishment*, edited by G. Becker and W. Landes. New York: National Bureau of Economic Research.

Becker, Howard S. 1963. *Outsiders.* New York: Free Press.

Beling, Joel, Hudson, Stephen M., and Tony Ward. 2001. "Female and Male Undergraduates' Attributions for Sexual Offending Against Children." *Journal of Child Sexual Abuse* 10: 61-82.

Belknap, Joanne. 2001. *"The Invisible Woman: Gender, Crime, and Justice."* Australia: Wadsworth.

Blacksmith, George. 2005. "Ride or Die." Urban Dictionary. Retrieved November 28, 2006 (http://www.urbandictionary.com/define.php?term=ride+or+die).

Bresler, Laura and Diane K. Lewis. 1983. Black and White Women Prisoners: Differences in Family Ties and Their Programmatic Implications. *The Prison Journal* 63: 116-123.

Brickman, Phillip. 1982. "Models of Coping and Helping." *American Psychologist* 37: 368-384.

Bridges, George S. and Sara Steen. 1998. "Racial Disparities in Official Assessments of Juvenile Offenders: Attributional Stereotypes as Mediating Mechanisms." *American Sociological Review.* 63: 554-570.

Bureau of Justice Statistics. 1994. *Violent Crime.* Washington DC: U.S. Government Printing Office.

Bureau of Justice Statistics. 1995. *Violent Crime.* Washington DC: U.S. Government Printing Office.

Bureau of Justice Statistics. 1995. *Correctional Populations in the United States, 1995.* Washington DC: U.S. Government Printing Office.

Bureau of Justice Statistics. 1999. *Women Offenders.* Washington DC: U.S. Government Printing Office.

Bush-Baskette, Stephanie. 1999. The "War on Drugs": A War Against Women? Pp. 211-229 in *Harsh Punishment: International Experiences of Women's Imprisonment.* Boston: Northeastern University Press.

Bush-Baskette, Stephanie. 2000. "The War on Drugs and the Incarceration of Mothers." *Journal of Drug Issues* 30: 919-928.

Bush-Baskette, Stephanie. 2000. "The War on Drugs and the Black Female: Testing the Impact of the Sentencing Policies for Crack Cocaine on Black Females in the Federal System." Ph.D. dissertation, Department of Sociology, Rutgers State University, Newark, NJ.

Butler, Anne M. 1997. *"Gendered Justice in the American West: Women Prisoners in Men's Penitentiaries."* Urbana: University of Illinois Press.

Calhoun, Avery J. and Heather D. Coleman. 2002. "Female Inmates' Perspectives on Sexual by Correctional Personnel: An Exploratory Study." *Women & Criminal Justice* 13: 101-124.

California Department of Corrections and Rehabilitation. 2006. "Offender Information Services." Sacramento: CA: California Department of Corrections and Rehabilitation, Retrieved July 1, 2006 http://www.cdc.state.ca.us/OffenderInfoServices/Reports/OffenderInforma tion.asp).

Campbell, Anne. 1990. *The Girls in the Gang.* New York: Basil Blackwell.

Carroll, John S. and John W. Payne. 1976. The Psychology of the Parole Decision Process: A Joint Application of Attribution Theory and Information Processing Psychology. Pp. 13-32 in *Cognition and Social Behavior*, edited by J.S. Carroll and J.W. Payne. Hillside: Erlbaum.

Carroll, Rebecca. 1997. *Sugar in the Raw.* New York: Crown Trade Paperbacks.

Cernkovich, Stephen A., Giordano, Peggy C., and Jennifer L. Rudolph. 2000. "Race, Crime, and The American Dream." *Journal of Research in Crime and Delinquency* 37: 131-170.

Chan, Wendy and Kiran Mirchandani. 2002. *Crimes of Colour: Racialization and the Criminal Justice System in Canada.* Broadview Press: Canada.

Chandler, Theodore A., Shama, Deborah D., and Fredric M. Wolf. 1983. Gender Differences in Achievement and Affiliation Attributions: A Five Nation Study. *Journal of Cross-Cultural Psychology* 14: 241-246.

Charmaz, Kathy. 2000. "Grounded Theory: Objectivist and Constructivist Methods." Pp. 509-535 in *Handbook of Qualitative Research*, edited by N. Denzin and Y. Lincoln. Thousand Oaks: Sage Publications, Inc.

Chernoff, Nina W., and Rita J. Simon. 2000. "Women and Crime the World Over." *Gender Issues* 18: 5-20.

Chesney-Lind, Meda. 1997. *The Female Offender*. Thousand Oaks: Sage Publications.

Chesney-Lind, Meda. 1999. "Media Misogyny: Demonizing "Violent" Girls and Women." Pp. 115-140 in *Making Trouble: Cultural Constructions of Crime, Deviance, and Control*, edited by J. Ferrell and N. Websdale. Hawthorne, NY: Aldine De Gruyter.

Chesney-Lind, Meda and Noelie Rodriguez. 1983. "Women Under Lock and Key: A View from the Inside." *Prison Journal* 63: 47-65.

Cloward, Richard A. 1959. "Illegitimate Means, Anomie, and Deviant Behavior." *American Sociological Review* 24: 164-176.

Collins, Patricia H. 1998. *Fighting Words: Black women and the Search for Justice.* Minneapolis: University of Minnesota Press.

Collins, Patricia H. 2000. *Black Feminist Thought: Knowledge, Consciousness, and the Politics of Empowerment*. New York: Routledge.

Comack, Elizabeth. 1996. *Women in Trouble*. Halifax: Fernwood Publishing.

Connelly, Marie, Hudson, Stephen M., and Tony Ward. 1997. Attributions for Sexual Offending in Social Workers and Students. *Australian Journal of Social Work* 50: 29-34.

Cook, Sandy and Susanne Davies. 1999. *Harsh Punishment: International Experiences of Women's Imprisonment.* Boston: Northeastern University Press.

Cooley, Charles H. 1909. *Social Organization*. New York: Scribner.

Crawford, Charles, Chiricos, Ted, and Gary Kleck. 1998. "Race, Racial Threat, and Sentencing of Habitual Offenders." *Criminology* 36: 481-507.

Crittenden, Kathleen S. 1991. "Asian Self-Effacement or Feminine Modesty? Attributional Patterns of Women University Students in Taiwan." *Gender & Society* 5: 98-117.

Decker, Scott, Wright, Richard, and Robert Logie. "Perceptual Deterrence Among Active Residential Burglars: A Research Note." *Criminology* 31: 135-147.

Dodge, Mara L. 2002. *"Whores and Thieves of the Worst Kind": A Study of Women, Crime, and Prisons, 1835-2000.* Northern Illinois University Press: Dekalb.

Dutton, Donald G. 1986. "Wife Assaulter's Explanations for Assault: The Neutralization of Self-Punishment." *Canadian Journal of Behavioral Science* 18: 381-390.

Erez, Edna, Hassin, Yael., and Giora Rahav. 2000. "Women, Crime and Justice in Israel: An Update." *Gender Issues* 18: 59-74.

Faith, Karlene. 1999. "Transformative Justice versus Re-entrenched Correctionalism: The Canadian Experience." Pp. 99-122 in *Harsh Punishment: International Experiences of Women's Imprisonment.* Boston: Northeastern University Press.

Farr, Kathryn A. 2000. "Classification for Female Inmates: Moving Forward." *Crime & Delinquency* 46: 3-17.

Felson, Richard B. and Stephen A. Ribner. 1981. "An Attributional Approach to Accounts and Sanctions for Criminal Violence." *Social Psychology Quarterly* 44: 137-142.

Fincham, Frank D., and Thomas N. Bradbury. 1988. "The Impact of Attributions in Marriage: An Experimental Analysis." *Journal of social & Clinical Psychology* 7: 147-162.

Findley, Maureen J. and Harris M. Cooper. 1983. Locus of Control and Academic Achievement: A Literature Review. *Journal of Personality and Social Psychology* 44: 419-427.

Forsyth, Donelson R. 1980. "The Functions of Attributions." *Social Psychology Quarterly* 43: 184-189.

Free, Marvin D. Jr. 1996. *African Americans and the Criminal Justice System.* New York: Garland Publishing, Inc.

Frieze, Irene H., Whitley Jr., Bernard E., Hanusa, Barbara, McHugh, Maureen C., and Valerie A. Valle. 1978. "Attributions of the Causes of Success and Failure as Internal and External Barriers to Achievement in Women. Pp.

130

in Psychology of Women: Future Directions of Research, edited by J. Sherman and F. Denmark. New York: Psychological Dimensions.

Gaarder, Emily and Joanne Belknap. 2002. "Tenuous Borders: Girls Transferred to Adult Court." *Criminology* 40: 481-517.

Gardstrom, Susan C. 1999. "Music Exposure and Criminal Behavior: Perceptions of Juvenile Offenders." *The Journal of Music Therapy* 36: 207-211.

Gilfus, Mary E. 2006. "From Victims to Survivors to Offenders: Women's Routes of Entry and Immersion Into Street Crime." Pp. 5-14 in In Her Own Words: Women Offenders' Views on Crime and Victimization, edited by L. Alarid and P. Cromwell. Los Angeles: Roxbury Publishing Company.

Gillespie, Michael W. and John Galliher. 1972. "Age, Anomie, and the Inmate's Definition of Prison: An Exploratory Study." Pp. 465-483 in Research Planning and Action for the Elderly, edited by D. Kent, R. Kastenbaum and S. Sherwood. New York: Human Sciences Press.

Glaser, Barney G. and Anselm Straus. 1967. *The Discovery of Grounded Theory: Strategies of Qualitative Research*. Chicago: Aldine.

Glick, Ruth and Virginia Neto. 1977. *National Study of Women's Correctional Programs*. Washington D.C.: National Institute of Law Enforcement and Criminal Justice.

Goffman, Erving. 1963. *Stigma*. Englewood Cliffs: Prentice-Hall.

Grasmick, Harold G. and Anne L. McGill. 1994. "Religion, Attribution Style, and Punitiveness Toward Juvenile Offenders." *Criminology* 32: 23-46.

Harrison, Lisa A. and Cynthia W. Esqueda. 2000. "Effects of Race and Victim Drinking on Domestic Violence Attributions." *Sex Roles* 42: 1043-1057.

Harrison, Lisa A. and Cynthia W. Esqueda. 2001. "Race Stereotypes and Perceptions About Black Males Involved in Interpersonal Violence." *Journal of African American Men* 5: 81-92.

Harrison, Paige M. and Allen J. Beck. 2005. *Prison and Jail Inmates at Midyear 2004*. Washington D.C.: U.S. Department of Justice, Office of Justice Programs, Bureau of Justice Statistics.

Heidensohn, Frances M. 1985. *Women and Crime.* New York University Press: New York.

Heider, Fritz. 1958. *The Psychology of Interpersonal Relations.* New York: Wiley.

Hesse-Biber, Sharlene N. and Patricia Leavy. 2006. *The Practice of Qualitative Research.* Thousand Oaks: Sage Publications.

Hill, Susan M. 1999. *Does Race Matter? A Study of the Role of Race in the Identity Process of Incarcerated Black Women.* Ph.D. dissertation, Department of Education, Texas A & M University, TX.

Hoffman-Bustamante, Dale. 1973. "The Nature of Female Criminality." *Issues in Criminology* 8: 117-136.

Holsinger, Kristi. 2000. "Feminist Perspectives on Female Offending: Examining Real Girls' Lives." *Women & Criminal Justice* 12: 23-51.

Hui, Chi-Chiu H. 1982. "Locus of Control: A Review of Cross-Cultural Research." *International Journal of Intercultural Relations* 6: 301-323.

Jackman, Mary. 1994. *The Velvet Glove: Paternalism and Conflict in Gender, Class, and Race Relations.* Berkeley: University of California Press.

James, Joy and Tracy D. Sharpley-Whiting. 2000. *The Black Feminist Reader.* Malden: Wiley Blackwell.

Johnson, Paula C. 2003. *Inner Lives: Voices of African American Women in Prison.* New York: New York University Press.

Jones, Christopher S. 1995. "The Effects of Racial Stereotypic Crimes on Decision Making and Information-Processing Strategies." Ph.D. dissertation, Department of Psychology, Northern Illinois University, IL.

Kalven, Harry and Hans Zeisel. 1966. *The American Jury.* Boston: Little Brown and Co.

Kluegel, James, R. and Eliot R. Smith. 1986. *Beliefs About Inequality: Americans' Views of What Is and What Ought to Be.* Hawthorne: Aldine De Gruyter.

Kopper, Beverly A. 1996. "Gender, Gender Identity, Rape Myth Acceptance, and Time of Initial Resistance on the Perception of Acquaintance Rape Blame and Avoidability." *Sex Roles* 34: 81-93.

Krivo, Lauren J. and Ruth D. Peterson. 2000. "The Structural Context of Homicide: Accounting for Racial Differences in Process." *American Sociological Review* 65: 547-559.

Kruttschnitt, Candace, Gartner, Rosemary, and Amy Miller. 2000. "Doing Her Own Time? Women's Responses to Prison in the Context of the Old and the New Penology." *Criminology* 38: 681-718.

Lefcourt, Herbert M. 1972. "Internal Versus External Control of Reinforcement Revisited: Recent Developments". Pp. in *Progress in Experimental Personality Research* V. eds. B.A. Maher. New York: Academic.

Lefcourt, Herbert M. 1976. *Locus of Control: Current Trends in Theory and Research*. Hillsdale: Erlbaum.

Lightfoot, Lynn O. and David O. Hodgins. 1988. "A Survey of Alcohol and Drug Problems in Incarcerated Offenders." *International Journal of the Addictions* 23: 687-706.

Mann, Coramae R. 1996. *When Women Kill*. Albany: State University of New York Press.

Mann, Coramae R. and Marjorie S. Zatz. 1998. *Images of Color and Images of Crime:Readings*. Los Angeles: Roxbury Publishing Company.

Mathis, Frank O. and Martin B. Rayman. 1972. "The Ins and Outs of Crime and Corrections." Criminology 10: 366-373.

Maxwell, Sheila R. 2000. "Sanction Threats in Court-Ordered Programs: Examining Their Effects on Offenders Mandated Into Drug Treatment." *Crime & Delinquency* 46: 542-563.

Maxwell, Joseph A. 1996. *Qualitative Research Design: An Interactive Approach.* Thousand Oaks: Sage Publications.

McCormack, Julie, Hudson, Stephen M., and Tony Ward. 2002. "Sexual Offenders' Perceptions of Their Early Interpersonal Relationships: An Attachment Perspective." *Journal of Sex Research* 39: 85-91.

McKay, Meryl M., Chapman, James W., and Nigel R. Long. 1996. "Causal Attributions For Criminal Offending and Sexual Arousal: Comparison of Child Sex Offenders With Other Offenders." *British Journal of Clinical Psychology* 35: 63-75.

McMorris, Michael A. 2001. "Perceptions of Criminality." Ph.D. dissertation, Department of Sociology, Capella University, Minneapolis, MN.

Meyers, Marian. 1997. *News Coverage of Violence Against Women: Engendering Blame*. Newbury Park: Sage.

Monahan, Molly B. 2000. "How Journalists Represent Violence Against Women." *Southern Sociological Society*. New Orleans.

Mullings, Janet L., Pollock, Joycelyn, and Ben M. Crouch. 2002. "Drugs and Criminality: Results from the Texas Women Inmates Study." *Women & Criminal Justice* 13: 69-97.

Na, Eun-Yeong, Loftus, Elizabeth F. 1998. "Attitudes Toward Law and Prisoners, Conservative Authoritarianism, Attribution, and Internal-External Locus of Control: Korean and American Law Students and Undergraduates." *Journal of Cross-Cultural Psychology* 29: 595-615.

Nair, Elizabeth. 1994. "How Do Prisoners and Probationers Explain Their Predicament? An Attributional Analysis." *Psychologia* 37: 66-71.

Osberg, Timothy M. 1986. "Teaching Psychology in a Prison." *Teaching Psychology* 13: 15-19.

Owen, Barbara. 1998. *"In the Mix: Struggle and Survival in a Women's Prison."* State University Press of New York: New York.

Petrocelli, John V., Calhoun, Georgia B., Brian A. Glaser. 2003. "The Role of General Family Functioning in the Quality of the Mother-Daughter Relationship of Female African American Juvenile Offenders." *Journal of Black Psychology* 29: 378-392.

Pew Center on the States. 2008. "One in 100 Behind Bars in America 2008." Washington, D.C.: Pew Research Center.

Piquero, Alex and George F. Rengert. 1999. "Studying Deterrence with Active Residential Burglars." *Justice Quarterly* 16: 451-471.

Raeder, Myrna S. 1993. "Gender Issues in the Federal Sentencing Guidelines and Mandatory Minimum Sentences." *Criminal Justice*: 8: 20-63.

Richie, Beth. 1996. *Compelled to Crime: The Gender Entrapment of Battered Black Women.* Routledge: New York.

Ross, Edward. A. 1977. *Standing Room Only.* New York: Arno Press, Inc.

Ross, Lee and Richard Nisbett. 1991. *The Person and the Situation: Perspectives of Social Psychology.* New York: McGraw Hill.

Rotter, Julian B. 1966. "Generalized Expectancies for Internal Versus External Control of Reinforcement" *Psychology Monographs* 80: 1-28.

Rotter, Julian B. 1973. "Internal-External Locus of Control Scale." Pp. 227-234 in *Measures of Personality and Social Psychological Attitudes.* Eds. J.P. Robinson and R. P. Shaver. Ann Arbor: Institute for Social Research.

Rubin, Lillian. 1992. *Worlds of Pain: Life in the Working-Class Family.* New York: Basic Books.

Schneider, Lawrence J., Ee, Juliana S. and Harriet Aronson. 1994. "Effects of Victim Gender and Physical vs Psychological Trauma/Injury on Observers' Perceptions of Sexual Assault and Its Aftereffects." *Sex Roles* 30: 793-808.

Scott, Marvin E. and Stanford M Lyman. 1968. "Accounts." *American Sociological Review* 33:46-62.

Scully, Diana. (1990). *Understanding Sexual Violence: A Study of Convicted Rapists.* New York: Routledge.

Sommers, Samuel R. and Phoebe C. Ellsworth. 2000. "Race in the Courtroom: Perceptions of Guilt and Dispositional Attributions." *Personality & Social Psychology Bulletin* 26: 1367-1379.

Straus, Anselm and Juliet M. Corbin. 1998. *Basics of Qualitative Research: Techniques And Procedures for Developing Grounded Theory.* Thousand Oaks: Sage.

Sullivan, Susan C. 2006. "The Work-Faith Connection for Low-Income Mothers: A Research Note." *Sociology of Religion* 67: 99-108.

Surrette, Ray. 1992. *Media, Crime, and Criminal Justice images and Realities.* California: Brooks/Cole Publishing Company.

Sutherland, Edwin H. 1939. *White Collar Crime.* New York: The Dryden Press, Inc.

Thomas, William. I and Dorothy S. Thomas. 1928. *The Child in America.* New York: Alfred Knopf.

Tischler, Henry L. 2004. *Introduction to Sociology.* 8th Edition. Belmont: Thomson-Wadsworth.

Tolli, Adam P., and Aaron M. Schmidt. 2008. "The Role of Feedback, Causal Attributions, and Self-Efficacy in Goal Revision." *Journal of Applied Psychology* 93: 692-701.

Tonry, Michael. 1994. "Racial Disproportion in US Prisons." *British Journal of Criminology* 34: 97-113.

Tonry, Michael. 1995. *Malign Neglect—Race, Crime, and Punishment in America.* New York: Oxford University Press.

Tonry, Michael. 1997. "Ethnicity, Crime, and Immigration." *Overcrowded Times* 8: 9-10.

Uniform Crime Reports for the United States. 1995. Washington DC: U.S. Government Printing Office.

United States Department of Justice. 1991. *U.S. Department of Justice, Antitrust Division, Paralegal Program.* Washington DC: U.S. Government Printing Office.

United States Department of Justice. 1995. Sourcebook of Criminal Justice Statistics. Washington DC: U.S. Government Printing Office.

United States Department of Justice. 1999. *Sourcebook of Criminal Justice Statistics—Bureau of Justice Statistics.* Washington, DC: U.S. Government Printing Office.

U.S. Bureau of the Census. 2000. *Census of Population and Housing 2000.* Washington, DC: U.S. Government Printing Office.

Watterson, Kathryn. 1996. *Women in Prison: Inside the Concrete Womb.* Boston: Northeastern University Press.

136

Weiner, Bernard. 1974. *Achievement Motivation and Attribution Theory.* Morristown: General Learning Press.

Weiner, Bernard. 1986. *An Attributional Theory of Motivation and Emotion.* New York: Springer-Verlag.

Wood, Peter B. and Harold G. Grasmick. "Toward the Development of Punishment Equivalencies: Male and Female Inmates Rate the Severity of Alternative Sanctions Compared to Prison." *Justice Quarterly* 16: 19-50.

Young, Diane S. 2000. "Women's Perceptions of Health Care in Prison." *Health Care for Women International:* 21: 219-234.

Young, Vernetta and Rebecca Reviere. 2006. *Women Behind Bars: Gender and Race in US Prisons.* Boulder: Lynne Rienner Publishers, Inc.

Zhang, Lening, Messner, Steven F., and Zhou Lu. 1999. "Public Legal Education and Inmates' Perceptions of the Legitimacy of Official Punishment in China." *British Journal of Criminology* 39: 433: 449.

INDEX

A

Abandonment issues, 81
Abuse histories, 14
Abuse, 1, 8, 9, 14-17, 21, 40, 53-55, 64,
 65, 67-69, 72-74, 78-80, 83-86, 88,
 93, 101, 105-108
Achievement settings, 41
Addiction, 14, 53, 60, 65, 72, 83, 96
Adulthood, 21, 67, 69, 73
Albonetti, C., 27, 125
Alcohol use, 55
Alcohol, 13, 55, 75
Alcoholic beverages, 35
Alternative sanctions, 29
American Correctional Association, 10
American cultural narrative, 37, 39, 90,
 94
American identity, 37
American individualism, 38
Analytical framework, 45
Angelou, M., 78
Arnold, R., 1, 11-14, 59, 125
Aronson, H., 26, 134
Ascribed characteristics, 12
Asian women, 50, 86, 98, 101, 107
Assault, 35, 40, 58, 75, 77, 80, 105
Association, 12-14
Attica Correctional Facility, 32
Attribution theory, 3, 25, 35, 39, 99
Attribution(s), i, ii, 1-5, 14, 18, 19, 21
 23-26, 28, 35, 36, 38-42, 48, 50-52,
 58, 71, 73, 76, 80, 86, 88, 97-101,
 103
Attributional models, 42, 43, 52
Attributional styles, 40
Attributions of prisoners, 42

B

Babcock, L., 37, 39, 125
Bad relationships, 78
Bae, H., 19, 42, 51, 125
Bailey, A., 6, 125
Bank, B., iii, 41, 125
Basic needs, 21, 93, 109, 110

Battered Black women, 14
Beck, A., 6, 130
Behavioral consequences, 19, 42, 72
Beliefs, 23, 26
Beling, J., 28, 126
Belknap, J., 18, 21, 126, 130
Black defendants, 27, 35, 36
Black family, 77, 90
Black jurors, 36
Black males, 35
Black men, 22, 35, 51, 54, 57, 88-90,
 93, 97, 99, 101, 102, 108
Black women inmates, 4, 5, 50-53, 57,
 58, 71, 72, 74, 76, 78-80, 82, 88,
 94, 97, 99-103
Black women offenders, i, 2, 24, 36, 43,
 47, 50, 56, 79, 94, 100
Blacksmith, G., 72
Blurred boundaries, 21
Boyfriends, 54, 55, 58, 61, 69, 78
Boys, 66, 70
Brickman, P., 2, 19, 42, 51, 55, 126
Bridges, G., 27, 126
Bureau of Justice Statistics, 6-8, 126,
 130, 135
Bureau of Justice Statistics, special
 report, 7
Burglary, 31, 58, 76, 79
Bush-Baskette, S., 1, 8, 16, 17, 59, 70,
 126, 127
Buster(s), 72, 73, 75-77, 82, 86, 88, 89,
 90

C

Calhoun, A., 127
Calhoun, G., 133
California, iii, 6, 45-47, 56, 65, 102,
 125, 127, 131, 135
California Institution for Women (CIW),
 iii, 45-47, 50, 52, 56, 96, 102, 110,
 115, 120-122
California prisons, 6
Campbell, A., 59, 127
Canada, 16-19, 27, 127

138

Canadian Human Rights Commission, 17
Caretaking, 66
Carroll, J., 5, 9, 31, 127
Causal attribution, ii, 2, 4, 5, 19, 2, 49, 51, 57, 58, 72, 100
Causal judgment, 41
Causal relationships of crime, 26, 52
Census, 6
Central California Women's Facility, 15
Chandler, T., 40, 127
Chapman, J., 27, 133
Checks, 11, 18, 60, 61, 63
Chemical addiction, 63
Chesney-Lind, M., 1, 14, 22, 53, 101, 128
Child abuse and neglect, 12
Child sex offenders, 28
Childhood experiences, 66
Childhood, 9, 20, 21, 49, 53, 65, 67-69, 73, 101, 105, 120
Children, 15, 27-29, 33, 47, 49, 54, 55, 58, 61, 63, 65, 69, 76, 77, 83, 84, 91, 95, 105-110, 113
China, 29, 136
Chinese society, 30
Class oppression, 12, 20, 94
Class, 10, 12-14, 16, 18-21, 39, 57, 71, 94
Classism, 18
Client-counselor relationships, 42
Cloward, R., 59, 128
Clubber(s), 72-75, 78-80, 82-84, 86-89, 91, 93, 100
Coding categories, 45, 53, 56
Coercion, 14, 47
Coleman, H., 41, 127
College students, 35
Collins, P., 39, 126
Compelled to Crime, 14, 134
Confidentiality, 48, 52
Consent, 48, 115, 119
Consequences of attributions, 25, 52
Conspiracy, 58, 79
Controlled substance, 58
Cook, S., 15, 16, 128
Cooley, C., 23, 128
Cooper, H., 36, 129
Coping, 12, 42

Correction officers, 41
Correctional personnel, 41
Courts, 11
Cousins, 67, 68, 70
Crack cocaine, 8
Credit cards, 11, 63
Criminal behavior, i, 1, 4, 11, 26, 34, 39, 45, 48, 54, 65, 72, 73, 97, 103
Criminal sanctions, 29
Criminalization, 12-14, 20
Crittenden, K., 2, 19, 40, 42, 51, 55, 125, 128
Crouch, B., 11, 133
Crystal, 74, 83, 86

D

Data collection, iii, 45
Davies, S., 15, 16, 128
Dayrooms, 47
de Tocqueville, A., 37
Debriefing, 52
Decisions to parole, 5
Decker, S., 28, 31, 33, 129
Defeatism, 2, 19, 42, 51
Demographic data, 49
Demographic questions, 49
Demographics form, 48
Destiny, 36, 51, 93, 94
Deterrence, 28, 31, 33
Differential association theory, 13
Differential treatment, 12
Digital recorder, 52
Digital recording, 49
Diminished motivation, 19, 42, 51
Discussion, 6, 22, 35, 45
Dispositional factors, 26
Division of labor, 66
Dodge, M., 19, 127
Domestic chores, 66
Domestic violence, 35, 101
Dope, 84, 91
Drive reduction theory, 34
Drug addiction, 21, 63-65
Drug and alcohol counseling, 96
Drug related offenses, 84
Drug sales, 53, 58, 78, 103
Drug talk, 75
Drug transportation, 78
Drug use, 16, 21, 40, 73, 89, 100, 101

Drugs, 16, 17, 27, 53-55, 58, 60, 63-65, 71-75, **80**, 82-89, 91, 93, 96-102, 105-108, 120
Dutton, D., 40, 129

E
Early childhood, 21, 66, 67
Economic marginality, 12
Education, 9, 12, 28-30, 46, 49, 55, 79, 85, 89, 91, 109, 110
Ee, J., 26, 134
Ellsworth, P., 36, 134
Emotional abuse, 9
Employment, 12, 55, 109, 110
Environmental causes, 94
Environmental factors, 24, 94, 99
Esqueda, C., 35, 130
Excitation-transfer theory, 34
Expectations for the future, 19, 42, 51
Explanations, 11, 26, 27, 39, 40, 50, 72, 94
Extended family, 54, 55, 58, 67
External, i, 3, 22, 24-28, 36, 39-43, 50, 51, 57, 58, 71, 74, 80, 86, **88**, 93, 94, 97-103
External attributions, i, 3, 22, 26, 40, 41, 50, 57, 99-101
External causality, 28
External causes, 40, 100, 102
External explanations, 41, 50
External factors, 41, 101
External loci of control, 25
external-external, 42
External-internal, 42
Extortion, 58, 79
Extralegal factors, 54

F
Faith, K., 17, 18, 129, 134
Familial relationships, 12
Family, iii, 11-15, 20, 34, 42, 60, 61, 65-67, 78, 80, 83, 85, 90, 91, 95-97, 106-110
Family friends, 67
Family life, 65
Family members, 14, 95, 105-110
Family violence, 12
Fast money, 91
Fate, 37, 38, 51, 93

Father(s), 12, 34, 47, 49, 67, 68-71, 96
Felson, R., 39, 129
Female attributional style, 40
Female offenders, i, 2, 3, 6, 9, 11, 18, 20, 22, 24, 25, 29, 45, 47, 50-53, 57, 80-82, 84, 86, 94, 97, 99, 100, 102
Female perpetrated homicides, 13
Female prisoners, 11, 41, 45, 48, 49, 56, 73, 97
Female violence, 13
Feminist criminologists, 2
Feminist criminology, 11
Feminist literature, 2, 5
Fictive kin, 67, 95, 105-110
Fighting back, 14, 73
Findley, M., 36, 129
First Nations women, 18
Forgery, 11, 58, 106
Forsyth, D., 2, 19, 42, 51, 55, 129
Fraternization, 55
Frieze, I., 40, 129
From Pathways to Attributions, vi, 10
Fundamental attribution error, 28, 75
Future, i, 2-4, 7, 22, 24, 25, 38, 42-45, 48, 49, 52, 55, 57, 73, 95-97, 99, 100, 102, 108-111, 115
Future criminal behavior, 48, 115
Future outcomes, 2

G
Gaarder, E., 18, 21, 130
Galliher, J., iii, 24, 95, 102, 116, 117, 130
Gambling addiction, 60
Gang bangers, 68, 87
Gangs, 70, 87, 88, 92, 93
Gardstrom, S., 34, 130
Gender bias, 39
Gender, race, attributions for crime
Gendered attributions, 51, 52
Gendered dimension of crime, 6
Gender-identity development, 14
General public, 10, 23, 26, 36, 43, 49, 51, 83
Gilfus, M., 20, 21, 67, 101, 130
Gillespie, M., 24, 95, 102, 130
Girlfriends, 54, 55, 58

Girls, 6, 9, 11, 12, 14, 20-22, 65, 66, 79,
 80, 83, 85, 86, 88
Glaser, B., 29, 34, 130, 133
Glick, R., 9, 130
Goals, 3, 36
Godfathers, 67, 68
Grandparents, 47
Grasmick, H., 20, 28, 29, 130, 136

H

Hanusa, B., 40, 129
Harrison, L. 128
Harrison, P., 15
Harsh Punishment: International
 Experiences of Women's
 Imprisonment, 126, 129
Hayes, J., 6, 125
Heidensohn, F., 1, 9, 11, 131
Heider, F., 25, 97, 131
Helping, 42, 87, 96
Heroin, 74, 82, 83
Hesse-Biber, S., 48, 131
Hill, S., 9, 129, 134
Hispanic women, 7, 87
Hodgins, D., 27, 132
Hoffman-Bustamante, D., 59, 131
Holsinger, K., 18, 131
Homies, 53-55, 71, 80, 85, 87, 88, 93,
 105-108
Hopes and dreams, i, 3, 4, 22, 24, 52,
 55, 95-97, 99, 108-111, 115
Housing units, 47
Housing, 47, 55
Hudson, S., 28, 33, 126, 128, 132
Husbands, 58, 61, 69, 78, 81

I

Identity theft, 58, 77, 105
Ideology, 38, 39, 90, 94
Illicit drugs, 75
Implications, 4, 19, 38, 42, 51, 99, 100
In The Mix: Struggle and Survival in a
 Women's Prison, 15, 133
Incest, 12, 16, 17, 21
Incompetent muddler model, 42, 43
Incorrigibility, 13
Individualism, 37-39, 90, 94
Inequality, 39

Informants, i, 3, 46-49, 52-57, 61-63,
 67, 72, 73, 95, 97, 101
Inmates, i, 2-4, 7, 8, 17, 21, 23, 24, 27,
 29, 32, 38, 39, 41, 43, 46, 48-52,
 57, 58, 60, 63, 64, 66-74, 76, 79-
 80, 84-89, 92-97, 99-103, 117
Institutional racism, 90
Intergenerational poverty and welfare,
 12
Internal, i, 3, 22, 26-28, 36-43, 50, 51,
 54, 57, 58, 71, 74, 80, 86, 88, 93,
 94, 97, 99-103, 115
Internal attributions, 26-28, 38, 40, 41
Internal causes, 27
Internal explanations, 50
Internal factors, 36, 51, 93
Internal locus of control, 36-38, 93, 94
Internal-external, 38, 39, 42, 50
Internal-internal, 42
Interpersonal violence, 35
Interracial cases, 36
Intersectionality, 39
Interview process, 48
Interview tapes, 52
Interviews, 11, 15, 19, 20, 48, 49, 52,
 53, 56, 97, 99, 100, 103, 111, 116
Introductory psychology, 32

J

Jackman, M., 37, 38, 94, 130
Jails, 3, 5, 7-9, 11, 20, 103
James, J., 39, 129, 133
Johnson, P., 1, 8, 19, 20, 131
Jones, C., 27, 35, 131
Journalists, 26
Judgments of suitability, 5
Justifications, 39
Juvenile offenders, 34

K

Kalven, H.27, 130
Kelly, G., 93
Kidnapping, 58
Kluegal, J., 23, 25

L

Labeling, 12, 13
Larceny, 11, 18
Laschever, S., 37, 39, 125

Lawfulness, 55, 56, 97, 108-110
Leavy, P., 48, 131
Lefcourt, H., 36, 132
Legal system, 36
Leisure activities, 55
Life chances, 86
Life experiences, iii, 3, 20, 33, 37, 48, 49, 65, 69, 105, 115, 116, 120
Life history interviews, 10, 14, 20
Lifers, 78, 102
Lightfoot, L., 27, 132
Literature review, i, 3
Locus of control, 23, 36, 37, 40, 50-52, 93, 94, 97
Loftus, E., 26, 133
Logie, R., 28, 33, 129
Long, N., 5, 10, 19, 36, 63, 62, 63, 69, 71, 76, 93
Love, 60, 70, 77, 89, 93
Loved one(s), 53-56, 58, 62, 71, 72, 80, 85, 88, 95, 97, 98, 100, 105-110
Low self-esteem, 2, 17, 19, 42, 51, 53-55, 70-73, 76-78, 80, 81, 86, 88, 93, 97, 99, 105-108
Low wage employment, 12
Lu, Z., 28, 29, 136
Luck, 41
Lyman, S., 25, 39, 97, 134

M

Male attributional pattern, 40
Mandatory minimum sentencing laws, 8, 16
Mann, C., 13, 132
Marital status, 47, 49
Marx, Karl, 37
Mastery of adversity model, 42, 43
Material reasons, 81
Mathis, F., 24, 27, 97, 132
Maxwell, J., 28, 31, 32, 103, 132
McCormick, J., 28, 33, 34, 130
McGill, A., 26, 128
McHugh, M., 40, 127
McKay, M., 27, 131
McMaster Family Assessment Device (FAD), 34
McMorris, M., 27, 131
Media, 16, 26, 30, 49, 67
Medical model, 42

Mental and emotional abuse, 12
Mental health professions, 96
Messner, S., 28, 29, 136
Methamphetamine, 82, 83, 86
Methodological design, 45
Methods and procedures, ii, 3
Meyers, M., 26, 133
Mis-education, 12
Mock jurors, 36
Molestation, 12, 70, 71, 105
Monahan, M., 26, 133
Money, 31, 54, 59-65, 67, 71, 79-81, 85, 86, 89-91, 105-108
Moralistic model, 42
Morality, 37
Mother, 34, 49, 64-66, 68-71, 76, 79, 95, 96
Mullings, J., 11, 133
Murder, 58, 62, 63, 66, 70, 77, 79, 85, 87, 105

N

Na, E., 26, 114, 133
Nair, E., 2, 19, 42, 43, 51, 55, 133
Neglect, 18, 20, 21, 33, 53-55, 64, 65, 67, 68, 72, 78-80, 84, 86, 88, 93, 101, 105-108
Negotiation, 37
Neto, V., 130
New Zealand, 16, 27
Nisbett, R., 27, 28, 75, 97, 134
Noncriminal behaviors, 14
Non-violent offenses, 46

O

Offender based research, 28
Operational definitions, 45
Optimism, 19, 25, 42, 51, 102
Optimistic outlook, 2
Osberg, T., 28, 32, 133
Outcomes, 38, 76
Owen, B., 15, 67, 69, 101, 133

P

Parental authority, 14
Parental neglect, 53, 68
Parents, 12, 54, 55, 58, 67, 68, 71, 76, 83, 87, 93, 95, 105-110
Past criminal behavior, 48, 115

Pathways to crime, ii, 1, 2, 4, 5, 11, 14, 18, 20, 53
Patriarchy, 1, 12, 14
Payne, J., 5, 127
Perceived, 10, 19, 25, 28, 30, 32, 34-36, 41, 45, 49-51, 58, 62, 88, 91, 94, 97, 100-103
Perceiver, 25, 28, 36, 49-51, 100, 102
Perceptions, i, 1, 2, 4, 10, 19, 20, 22-25, 27-30, 32-37, 42, 45, 47, 49-52, 54-58, 71, 73, 80, 81, 85, 88, 91, 93, 99-101, 103, 105-108
Perceptions of health care, 32
Perceptions of interpersonal relationships, 28
Perceptions of prison education, 28
Perceptions of public legal education, 28
Perceptions of punishment, 28
Personal causes, 40, 43, 51, 94
Personal experiences, 91
Personal factors, 36, 51, 93, 94
Personal responsibility, 7, 24, 131
Personal responsibility, 37-40, 76
Petrocelli, J., 29, 34, 133
Petty thefts, 58
Pew Research Center, 24, 131
Physical abuse, 9, 12, 18, 21, 67, 70
Physical ailments, 2
Pills, 16, 66
Piquero, A., 28, 30, 31, 54, 133
Police, 11, 26, 62, 64
Pollock, J., 11, 133
Positive and negative feedback, 5
Possession, 8, 16, 58, 63, 64
Post-baccalaureate degrees, 46
Poverty, 14, 20, 27, 66, 79, 80, 101
Precriminal behavior, 11
Preliminary codes, 53
Prison for women (P4W), 17
Prisoners, 18, 27, 42, 48, 94
Prisons, 2, 5, 7-9, 11, 17-20, 77, 103
Procedures, 3, 45
Projection, 14
Promiscuity, 12
Property offenses, 8, 58
Prostitution, 10, 58, 65
Pseudo-families, 13
Psychological abuse, 67
Psychological aliments

Public information officer, 47, 48
Punishment equivalencies, 29
Punishment, 27, 29-31, 35

Q
Questionnaire, 47, 49, 52, 53, 56

R
Race, 1, 7, 13, 18-23, 27, 35, 36, 39, 49, 50, 57, 94, 98, 100, 102
Race stereotypes, 35
Race, class, gender oppression, 13, 20, 94
Racialized attributions, 19, 50, 52, 73, 101
Racism, 12, 14, 15, 18
Raeder, M., 7, 8, 132
Rape, 12, 16, 17, 26, 68-70, 105
Rayman, M., 24, 27, 97, 132
Reading, 48
Rebel, 66
Recidivism, 9, 19, 42, 43, 72
Recruiting participants, 47
Reflection-rejection theory, 34
Rehabilitation programs, 72
Religiosity, 26
Religious faith, 102
Rengert, G., 28, 30, 31, 54, 133
Repeat offenders, 46, 74
Repeating ideas, 47
Research questions, i, 3, 22, 57, 99
Research setting, 45
Residential burglars, 30, 33
Responsibility, 19, 35, 38, 40-42, 51, 65, 66
Restitution, 85
Results, ii, 4, 10, 20, 37, 90, 94, 103, 116
Reviere, R., 5, 136
Ribner, S., 39, 129
Richie, B., 1, 14, 22, 62, 70, 101, 134
Rider(s), 72, 75-77, 79-81, 84-89, 92
Rikers Island, 14
Risk factors, 90
Robberies, 58, 61
Robbery, 62, 70, 77
Rodriguez, N., 14, 128
Ross, L., 25, 28, 75, 99, 134
Rotter, J., 37, 51, 93, 134

Rubin, L., 67, 134
Running away, 11, 13, 14, 21

S
Same-race leniency, 36
Sample characteristics, 45
Schimdt, A., 5
Schneider, L., 26, 134
School, 9, 11-13, 36, 47, 64, 71, 87, 92, 113
Scott, M., 25, 39, 97, 127, 134
Scrapper(s), 72, 73, 78-80, 84-91, 93
Scully, D., 48, 134
Self-defense, 13
Self-effacing, 40
Self-enhancing, 40
Self-esteem, 2, 53, 54, 76, 77, 80-82, 86, 88, 93, 97, 100, 105-108
Self-worth, 2, 70, 81
Semi-structured interviews, 4, 47, 99
Setting, 3
Sexism, 15, 18
Sexual abuse, 9, 14-18, 20, 21, 41, 53, 67, 68, 79, 105-108
Sexual exploitation, 14
Sexual violence, 12
Shama, D., 40, 125
Sharpley-Whiting, T., 39, 129
Shoplifting, 11, 18, 63
Short-timers, 78
Siblings, 54, 55, 58, 62, 66, 67, 93, 95, 105-110
Significant others, 54, 55, 58, 78, 95, 105-110
Smith, E., 23, 25, 131
Social control, 1, 11, 14, 15
Social inference, 41
Social mores, 58
Social needs, 53, 67
Social perception, 41
Social psychology, ii, 19
Socio-structural attributions,
Socio-structural obstacles, 90
Sommers, S., 36, 132
Sourcebook of Criminal Justice Statistics, 8, 9, 54, 133
Spiraling marginality, 15
Spousal abuse, 84
Spouses, 54, 55, 58, 95, 105-110

Status offender, 12
Status offenses, 14
Steen, S., 27, 124
Stepfathers, 12, 68
Stereotypes, 20, 35
Structural analysis, 90
Structural conditions, 5, 11, 26
Structural dislocation, 12, 13
Students, 23, 26, 41, 43
Subculture of violence theory, 13
Substance abuse, 8, 20
Substance abuse program, 75
Sullivan, S., 102, 134
Surette, R., 26
Survival, 20-22, 54-55, 64, 71, 79, 80, 88, 89, 93, 97, 99, 105-108
Survival strategies, 20-22
Sutherland, E., 13, 135
Swarzennegger, A., 73

T
Television, 81
Texas, 6, 8, 131, 133
Texas Womens Inmate Study, 8, 131
The Female Offender, 14, 128
Themes, 1, 20, 21, 47
Theoretical constructs, 47
Theory, ii, 3, 11-13, 18, 23-25, 31, 33
Thomas, D. 23, 133
Thomas, W., 23, 133
"Three Strikes and You're Out" legislation, 6
Tianjin, 29
Tischler, H., 23, 133
Tolli, A., 5, 133
Tonry, M., 8, 54, 133
Traditional gender roles, 11
Transcribed tapes, 52, 114, 115, 117
Trends in women's imprisonment, 16
Truancy, 11, 12, 21
Typology, 2, 19, 21, 40, 45, 57, 71, 73

U
Uncles, 67, 68, 77, 85
Unemployment, 27, 55, 61
United States, 5-7, 16, 24, 27, 31, 126, 135
University of Missouri-Columbia, 111, 116, 117

Unlawfulness, 55, 56, 97, 108-110

V
Valle, V., 40, 129
Verbal abuse, 12
Victim, 10, 21, 26, 35, 40, 69
Victimization, 13, 18, 21
Victims, 8, 13, 22, 26, 35, 67
Violence, 12-14, 20, 21, 26, 35, 54, 75, 93
Violent crime, 8, 46, 54
Violent offenders, 8, 27, 34, 46, 58

W
War on Drugs, 16
Ward, T., 28, 33, 126, 128, 132
Watterson, K., 10, 135
Weber, M., 37
Weiner, B., 2, 19, 36, 42, 51, 55, 93, 136
When Women Kill, 13, 132
White defendants, 35
White males, 35, 36, 39
White men, 36
White women, 7, 22, 43, 50, 52, 54, 55, 57, 76, 80-86, 94, 97, 100, 102, 107, 110, 115
White-collar crimes, 58
Whitley Jr., B., 40, 129
Wife abuse, 40
Winfrey, O., 78
Wolf, F., 40, 127
Women and crime, 4, 10, 11, 99, 101
Women and Crime: The Life of a Female Offender, 11
Women held hostage, 14
Women in Prison: Inside the Concrete Womb, 10, 133
Women prisoners, 13, 17, 18, 43, 73, 97, 103
Women's pathways to crime, 1, 2, 5, 18, 53
Wood, P., 28, 29, 136
Work, i, ii, 1, 3, 4, 9, 13, 14, 21, 25, 31, 35, 37, 38, 41, 42, 64, 65, 89, 90, 90, 100
Wright, R., 28, 33, 129

Y
Young, D., 134
Young, V. 125

Z
Zeisel, H., 27, 131
Zhang, L., 28-30, 136

La Tanya Skiffer

Dr. La Tanya Skiffer is an Assistant Professor in the Sociology Department at California State University, Dominguez Hills. Dr. Skiffer completed her B.A. in Sociology at the University of Colorado-Denver, and her M.A. and Ph.D. in Sociology at the University of Missouri-Columbia. Her teaching and research areas of interest are Criminology, Law, Social Control and Deviance, Social Inequality, Social Organizations, and Social Psychology. Dr. Skiffer is also a veteran of the United States Army and a consultant with the Long Beach Boys and Girls Clubs.